BARBARA MORGAN

BARBARA MORGAN

Edited-designed by Barbara Morgan

Introduction by Peter Bunnell

A Morgan & Morgan Monograph

Morgan & Morgan, Inc.
Publishers
400 Warburton Avenue
Hastings-on-Hudson, N.Y. 10706

International Standard Book
Number 0-87100-034-2

Library of Congress Catalog Card
Number 72-92282
Printed in U.S.A.

To

WILLARD D. MORGAN

my husband and inspiration
with love and gratitude.

ACKNOWLEDGMENTS

My warm appreciation to:
Peter Bunnell for the Introduction,
to William Swan for the Chronologies,
and to Jan De Graff, Rikki Ripp and
Carolyn Lawrence for their darkroom,
studio and secretarial assistance
in making this book.

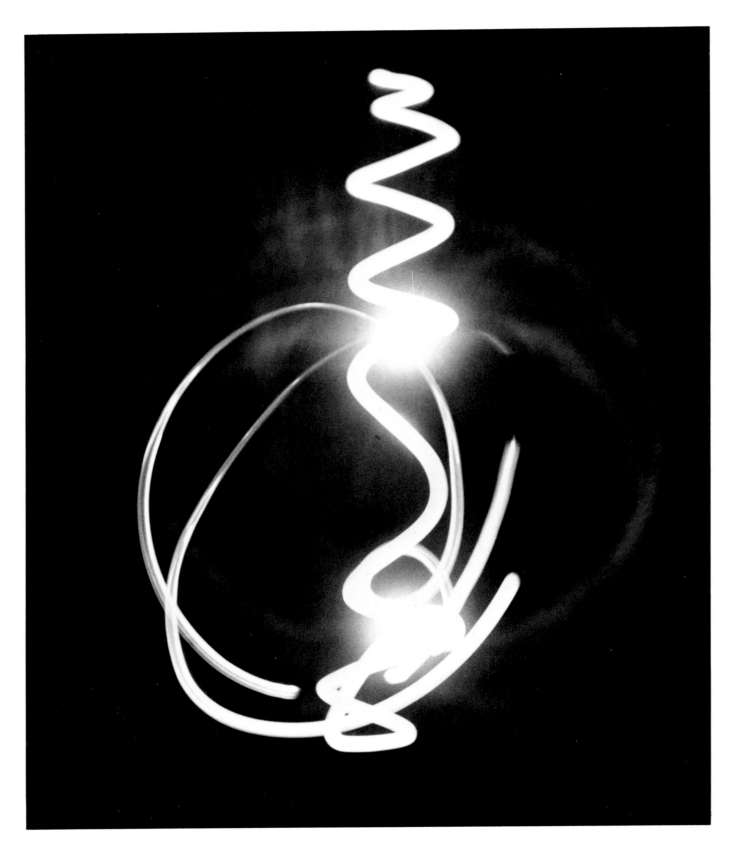

EMANATION I, 1940.

CONTENTS

INTRODUCTION

So highly does Barbara Morgan regard the ineffable, so profound has been her commitment to the dance, an expressive form which she describes as "the life force in action," and so sure is her sense of the intuitive, it is curious that she has found so complete a life in photography. For this medium, which generally is esteemed for its actuality, would seem not appropriate for her at all. But it is through the work of such an artist as Barbara Morgan that we may gain the understanding that above all else photography is a medium of interpretative expression and not of depiction, that photographs may be seen to represent imagination limited only by truth, and material facts raised to the power of revelation. To see Barbara Morgan's photographs is to experience the work of a versatile artist whose creative life spans five decades. Her photographs display an energy of both physical and psychic dimensions which clearly echo every aspect of her spirit and insight. The richness and physical scale of her photographs compel us to delve into their every recess and to become a participant in their vitality. For Barbara Morgan it is the gesture of largesse which speaks.

The subjects and techniques used in her work are varied: nature, man-made objects, people, the dance, light drawings, and photomontage. The dance photographs, begun in 1935 with Martha Graham and her company, are justifiably celebrated. They were made with a deep understanding of the cross-cultural sources and the dramatic or ritual schema of the dances, of kinetics, and with an assuredness in the technical complexities of the photographic medium. Working alone with her subjects, not in performance but in studios, and fundamentally out of her own creative needs, she recorded not so much the literal dance as the essential gestural aspect of life which the dance symbolized. Each dance was reconceived for the camera and its actions were condensed to those movements which were the most eloquent, the most complete. The connective movements of the overall rhythmic structure were omitted and the thematic movements, those which contain the essence of the dance, isolated, generally at the point of their climactic clarity.

It is interesting that these images should be referred to as *still* photographs. They are, of course, not cinematic in the usual sense of the term, and Barbara Morgan has made no attempt to structure her work in a linear sequence. The photographs, each of which is expressive of an aspect of a particular dance, primarily reflect the beauty of themselves as pictures. But these images are expressions of states of being relative to time, and while she respects the work of the dancers and choreographers, Morgan's aim has been to evoke the content of the dance without calling on the totality of the dance action. It was T.S. Eliot, I believe, who observed, that "at the still point, there the dance is," and it is clear that he understood

more than most the nature of the concept, referred to, especially in photography, as the *decisive moment*.

Barbara Morgan understands this concept very well. Writing in 1940, she observed that "previsualization is the first essential of dance photography. The ecstatic gesture happens swiftly, and is gone. Unless the photographer previsions, in order to fuse dance action, light and space expression simultaneously, there can be no significant dance picture."[1] Such an approach requires previous knowledge not only of the dance content, or story, but of what is photogenic; that is, what can be imparted through a picture which will result in its having an existence beyond that of being the record of an event. She has written elsewhere that, "When I am full of the subject, picture ideas and treatment spring to mind spontaneously and are not concocted. The power of an image to appear full-blown in my mind is proof of its vitality, and those that persist, I work on. Sometimes I will carry a picture idea in my mind for days and months, but when the moment comes, I like to shoot at a high pitch and develop as quickly as possible, to analyze errors or success while it is fresh. Of course, every step in the making cycle is integral, but I feel that the gestation in the beginning is 90% of the picture."

"In this *unforced* meditation," she continued, "I empty my mind and allow the memorable gestures which inspired the idea to replay themselves; then, while holding these forms clear, I envision trials of lighting, spacing, framing, as a rehearsal—until it clicks. This is especially necessary for such shooting as dance action, for there is not time for trials when the dancers must be kept invigorated by confident direction, together with camera and lighting control. Sometimes in actual shooting the imagined approach is found unworkable and given up for a quite different setup. Nevertheless, this imaginary rehearsal attunes one to essentials."[2]

Barbara Morgan often refers to the "rhythmic vitality" of her work. By this she means the translation of literal interpretation such as light and dark, love and hate, natural and man-made, all polarities of sorts, into a kind of visual dynamic. The body of her work must be viewed with this sense of parallels and perpendiculars; of children happy and sad, of a tree's delicacy and strength, of man's ruins and nature's fossils. In one sense, no single picture by her can espress the complexity of her thought, for the whole of her work, the design of her books and exhibitions, the sense of her total involvement, is one of a reciprocity between, the themes and forms of one image and those of another.

The essential readability of Barbara Morgan's photographs is very straightforward. I do not mean this in any pejorative sense, but rather as a way to characterize her approach to the expression of content. The Morgan photograph of an ecstatic, leaping man is exactly that, and a rusting automobile engulfed in a bed of weeds has to do with exactly what is shown— power, decay, growth, man, and nature. Likewise the luminous swirl of a light drawing may be seen to be the freehand equivalent in pure electric energy of Martha Graham's bodily swirl which, by its schema, symbolizes the transcendence of the heroine's personal tragedy in the dance, "Letter to the World." Similarly her titles for photographs, such as, "Pure Energy and Neurotic Man," "Fossil in Formation," "Saeta," and for one of the images described above, "Resurrection in the Junkyard," indicate both the literalness of her thought and the purposefulness of her intent.

Nowhere in her work can this sense of the literary be seen as clearly as in the book *Summer's Children,* which in every respect was created by the artist. This book, prepared in the late forties and "conceived as an affirmation of the art and science of human relationships. . .," is deceptively simple. At first viewing it appears to be about what children do at camp, but with reflection it may be seen that these are photographs of experiences, not of events. It could not be otherwise, because the author was not so much interested in what the children did, but in what effects each of their actions had. In other words, she was attempting to show the

evolving, quiet, yet profoundly moving and sometimes difficult process of human growth. Rather than describe these photographs as universal, it seems to me that they should be regarded as fundamental. In this way, the psychological appreciation of life will be grasped through the evocation of parallel memories in everyone and the burden of interpretation will reside properly with the viewer. It is a mistake to assume that a universally recognizable photograph means the same thing to all.

As opposed to straight photography in which the literal continuum of observation and reaction is maintained, Barbara Morgan sees the photomontage as more nearly approximating imagination itself. The multiple-image system of montage allows her to combine discontinuous thoughts, observations, and ideas into a visual metaphor and also to spontaneously create designs and patterns which relate to her continued interest in painting and graphics. Writing about this form, she has said, "As the lifestyle of the Space Age grows more interdisciplinary, it will be harder for the 'one-track' mind to survive, and photomontage will be increasingly necessary. I see simultaneous-intake, multiple-awareness and synthesized-comprehension as inevitable, long before the year 2000 A.D. It is a powerful means of creating relevant pictures. I feel that photomontage with its endless technological and esthetic possibilities can be not only an inspiring medium for the meditative artist, but that it will increasingly serve the general public as a coordinating visual language."[3]

Barbara Morgan is not widely known for her work in photomontage, and while she continues to use it today, her work from 1935 represents an exceptionally early articulation of this technique by an American. In general, her pictures reflect an urban lifestyle which lends itself to this fractured, layered structuring—strata of people, place, mood, and meaning. As designs, her earliest compositions are not unlike aerial photographs, or drawings for the constructivist sculpture or architecture which emerged in the decade of the twenties. The old solid order of things—once felt in the weight of objects—is now fragmented into components, and these are rearranged into shifting patterns in continuous movement through space.

Barbara Morgan's work in photomontage and dance is perhaps her most important photographically because it marked a change in the fabric of prewar American photography. It bridged the abstract and synthetic work developed in Germany and elsewhere in the twenties and the rigorous straightforward disciplines generally admired in this country and practiced by two of her close friends, Edward Weston and Charles Sheeler. It was also a connective between the natural, pictorial environment, which for her colleagues and predecessors was the landscape, and her interest in the human world and the urban architectonic. She has always viewed nature socially; as a macrocosm of details in which an intimate world of human experience and values may be found. In the end it is the question of human potential to which she has addressed herself throughout her work. Whether it be in the poetic aspiration to symbolize man's spirit or in the challenge to manipulate the physical craft of her medium, Barbara Morgan has exemplified, as only few others have, the true liberality of personal freedom.

Peter C. Bunnell

NOTES

1. "Photographing the Dance," Graphic Graflex Photography, Hastings-on-Hudson, N.Y.: Morgan & Morgan, 1971, p. 217.
2. "Kinetic Design in Photography," Aperture, 1:23, Number 4, 1953.
3. "My Creative Experience With Photomontage," Image, 14:20, December, 1971.

PHOTOGRAPHS

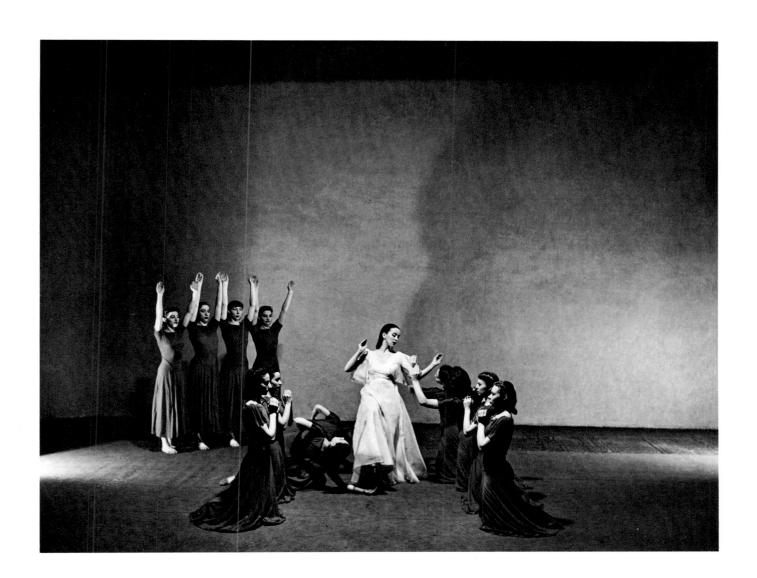

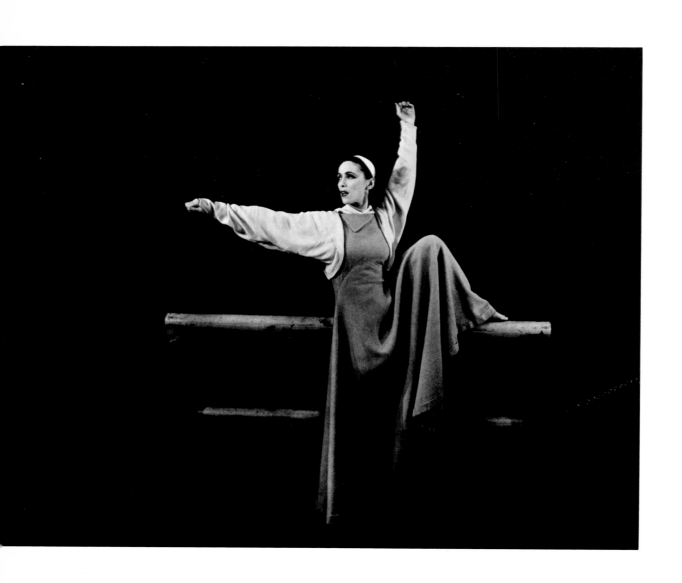

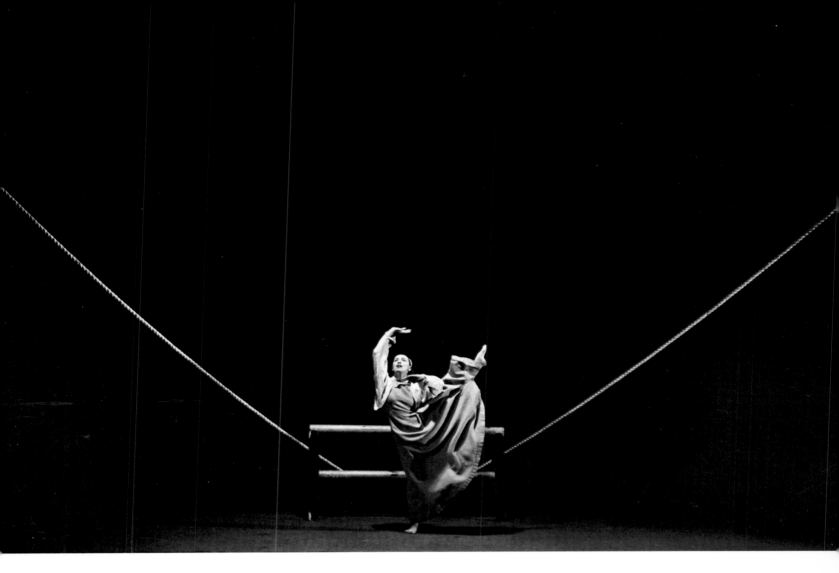

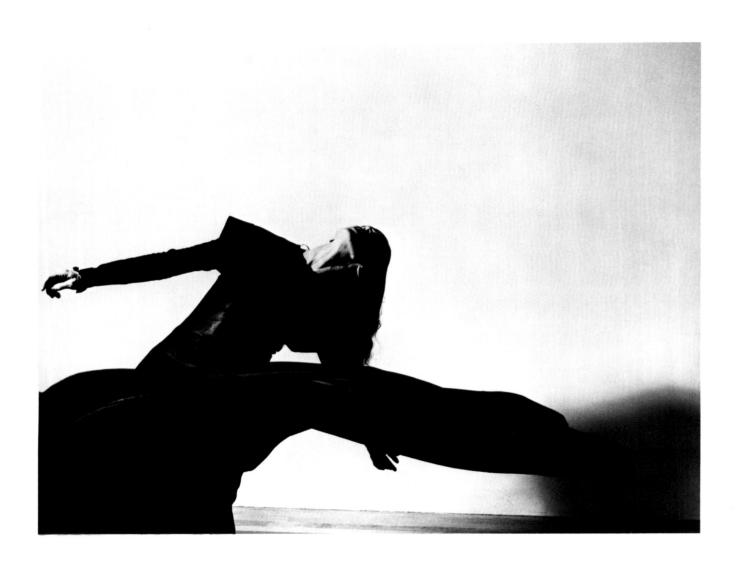

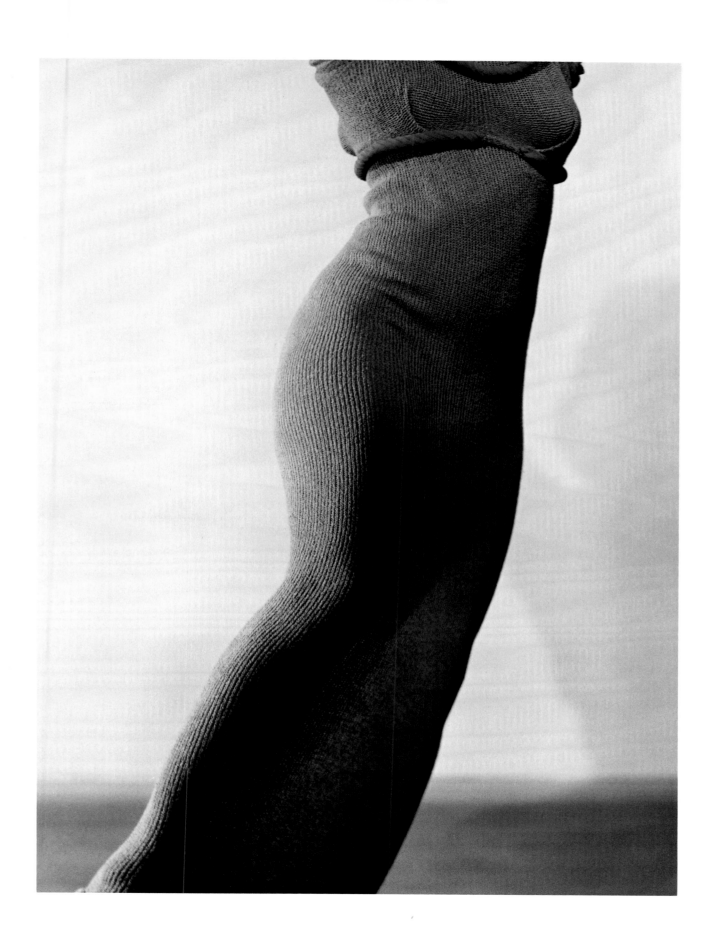

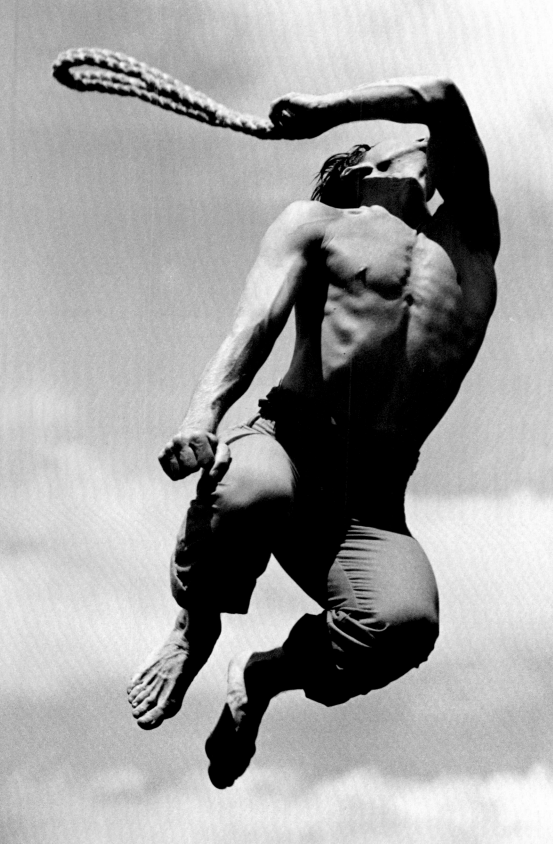

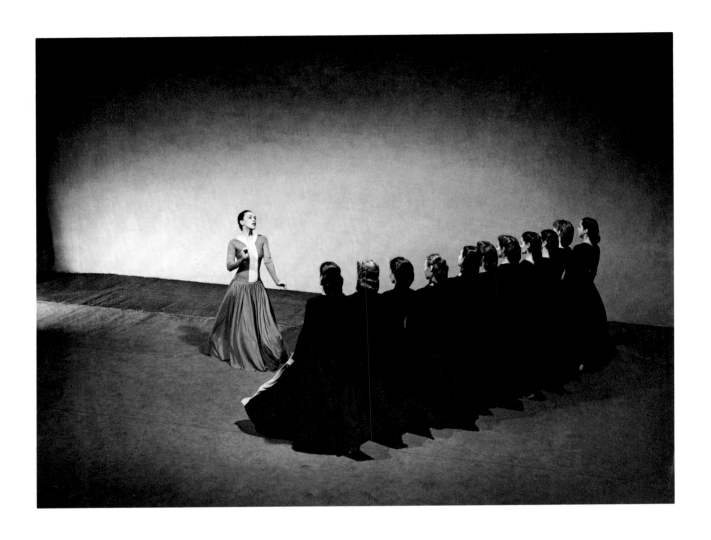

20 Martha Graham, AMERICAN PROVINCIALS (Group), 1935.
21 Martha Graham, LAMENTATION, 1935.

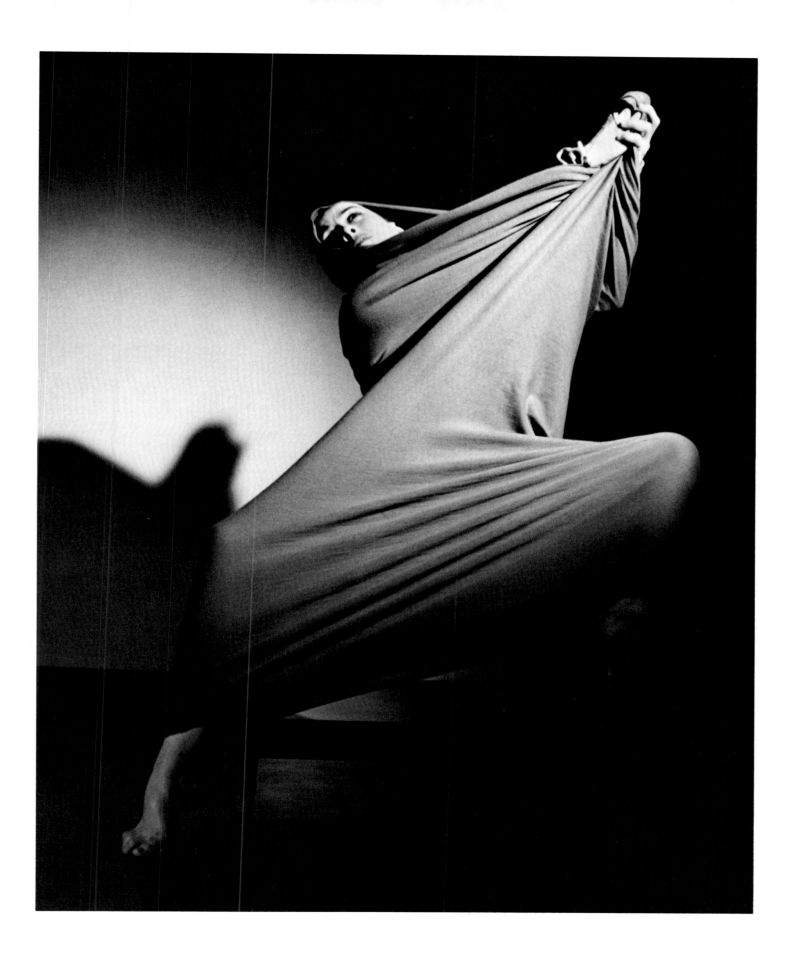

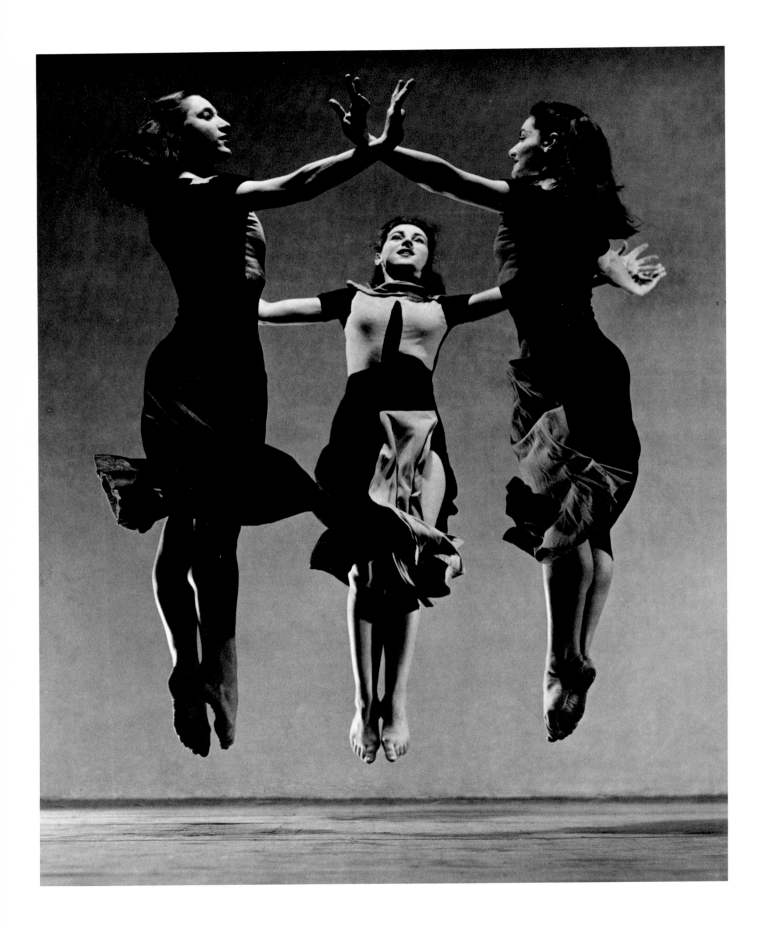

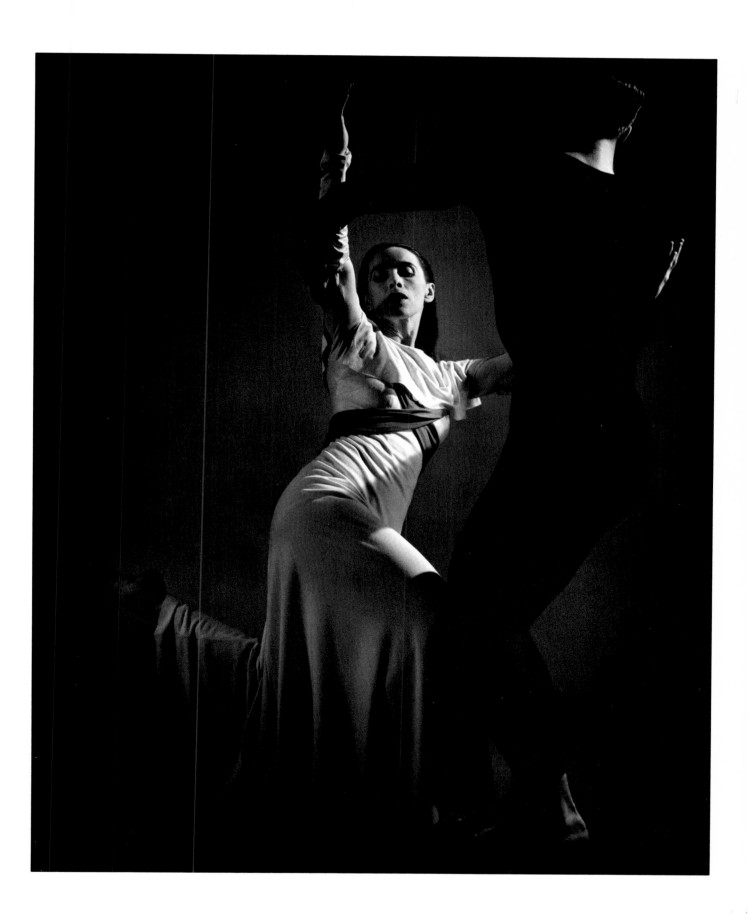

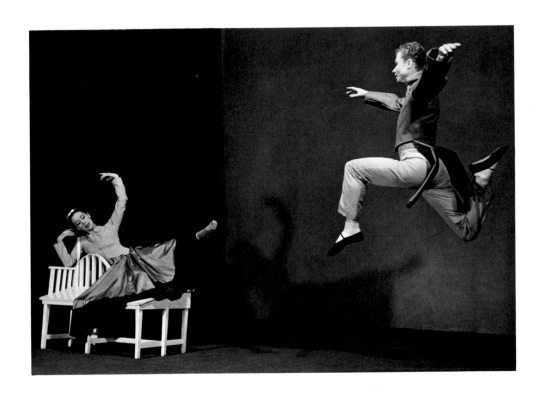

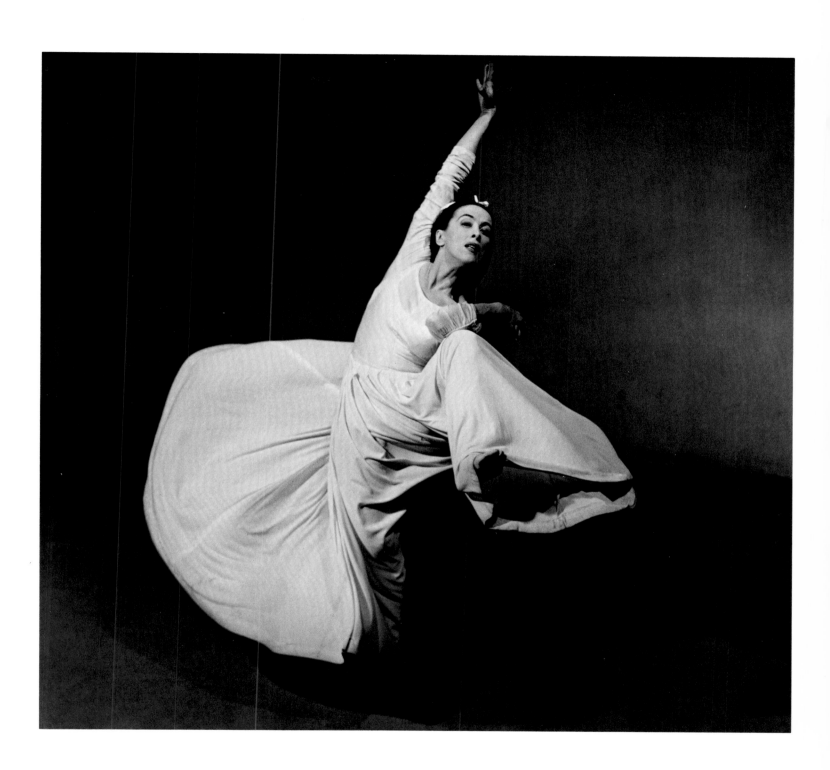

27 Martha Graham, LETTER TO THE WORLD (Kick), 1940.

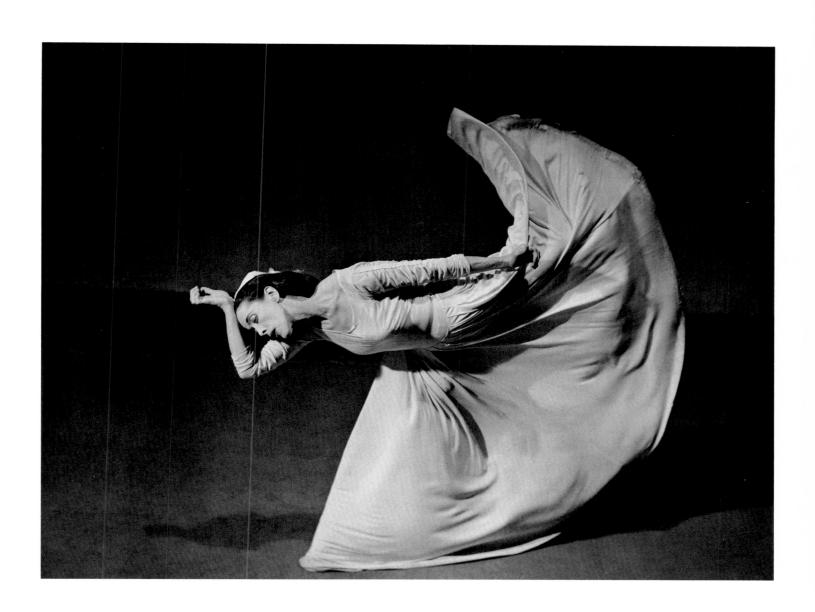

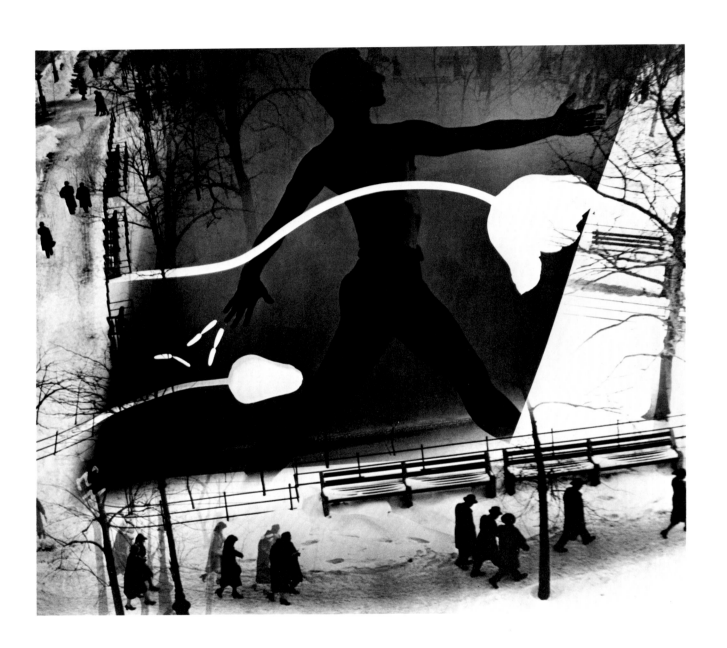

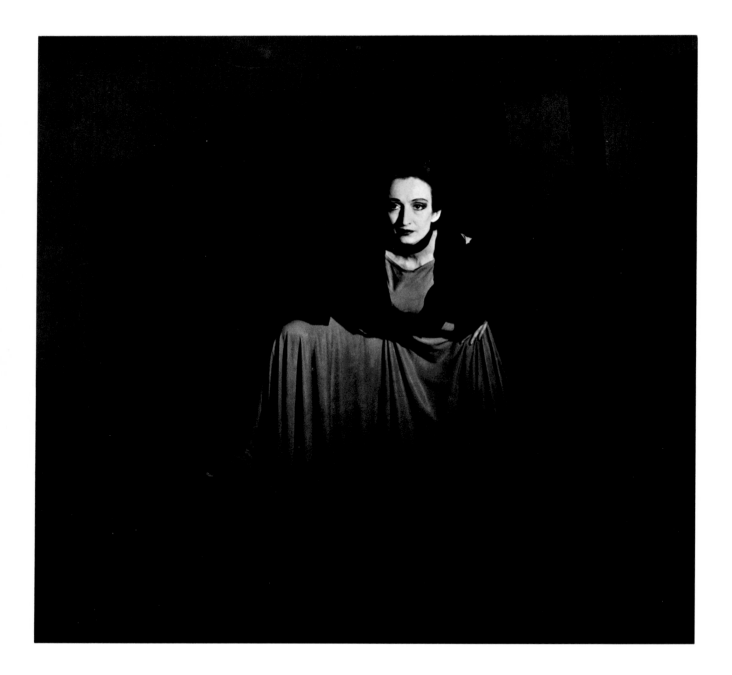

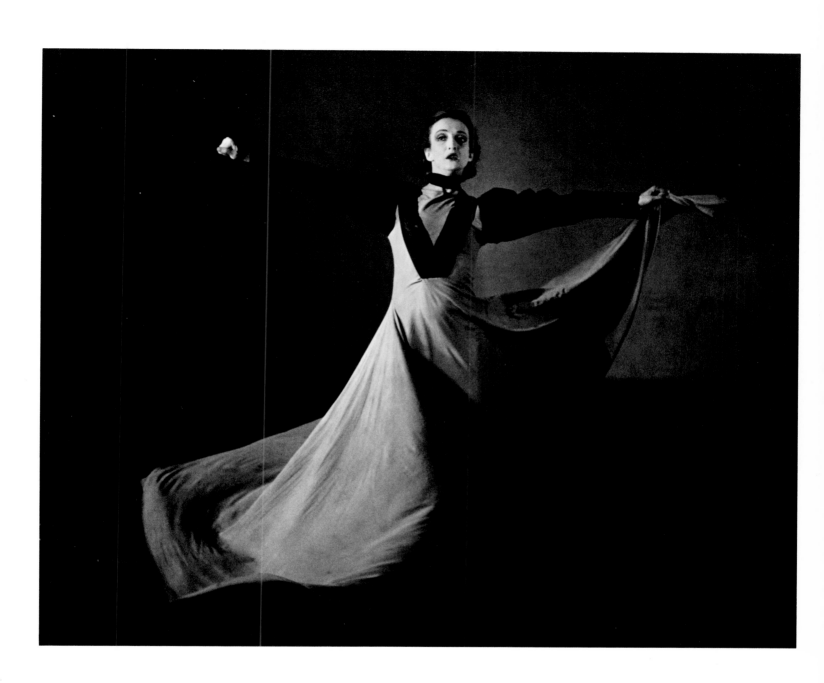

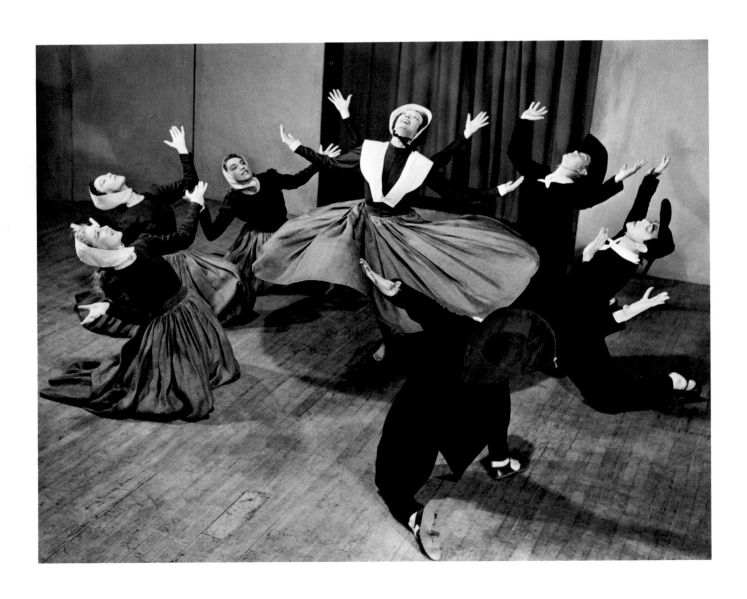

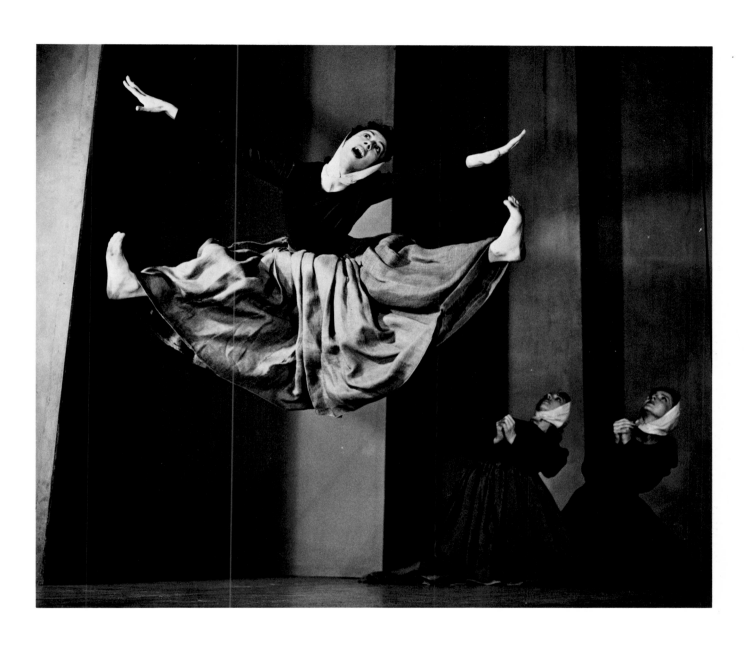

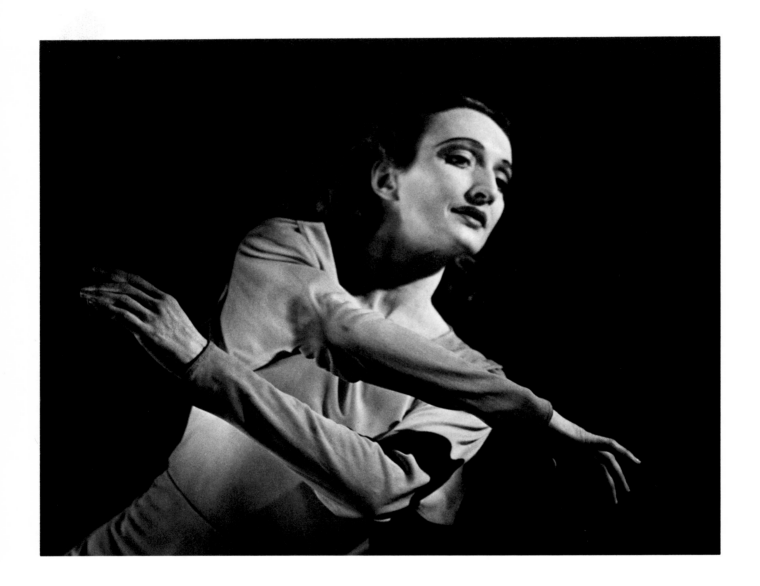

34 Doris Humphrey, TO THE DANCE, 1944.
35 Doris Humphrey, PASSACAGLIA, 1938.

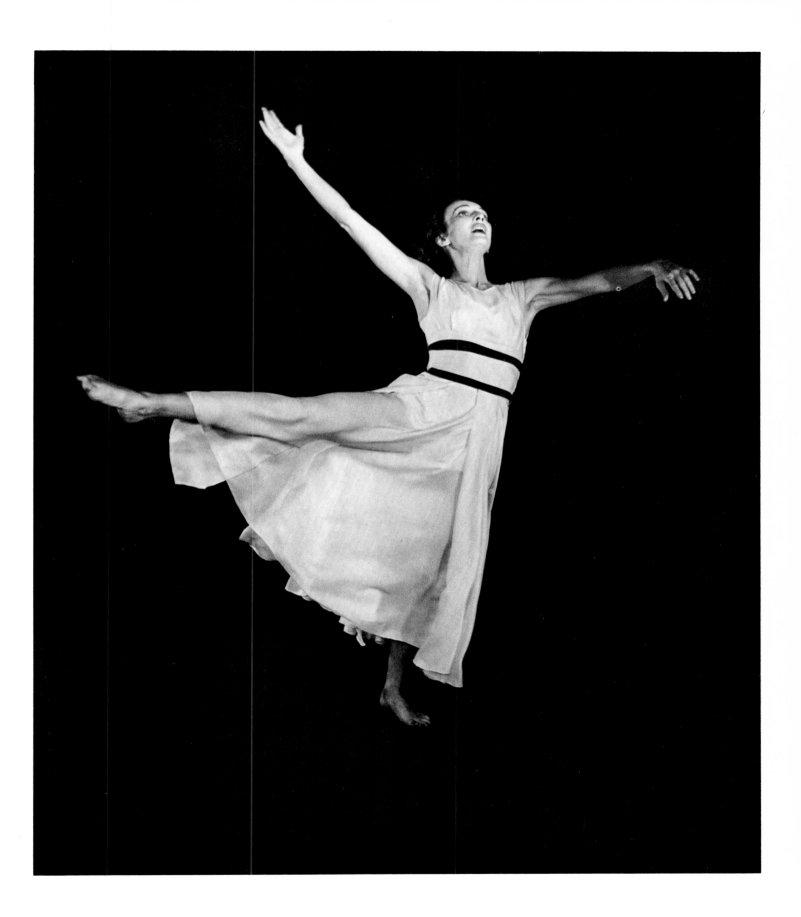

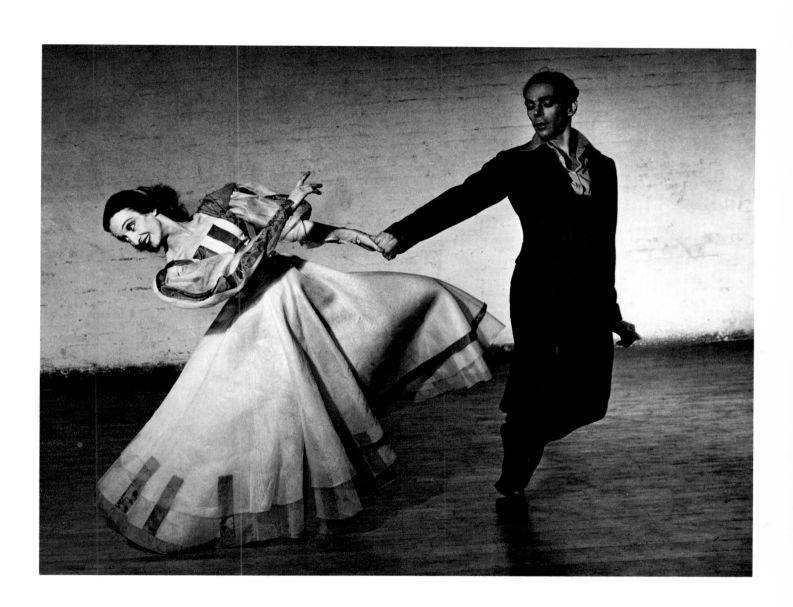

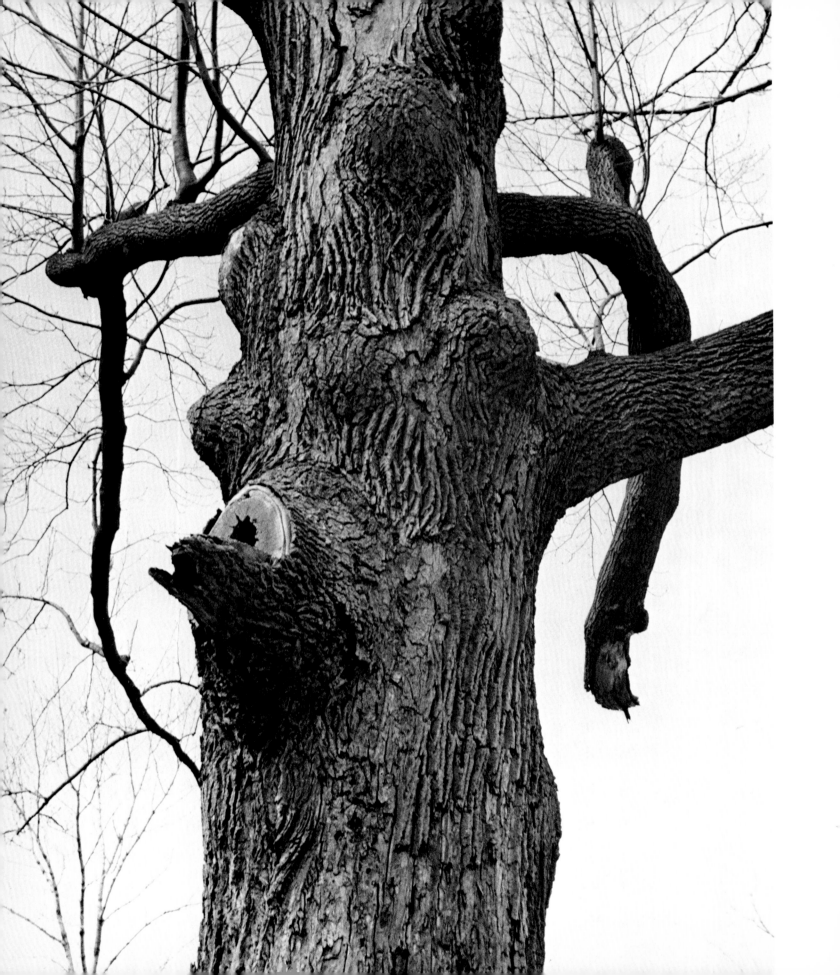

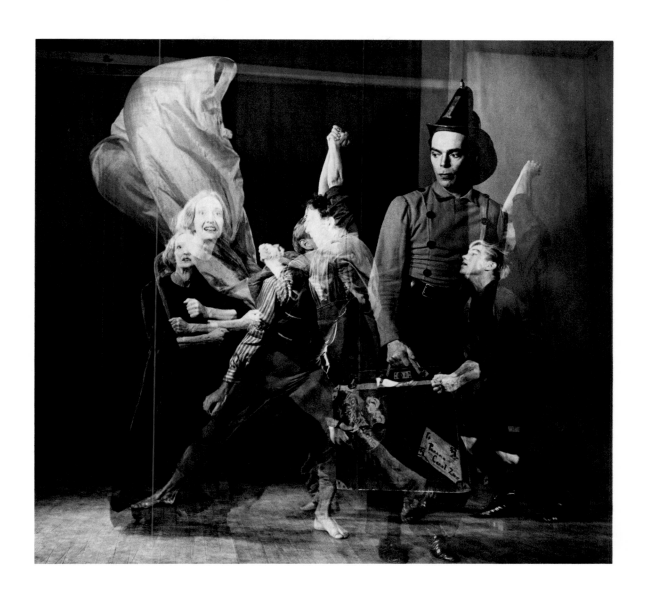

38 TREE TRUNK, 1948.

39 REHEARSAL NIGHTMARE (Photomontage with Humphrey, "Inquest" and Weidman, "Daddy Was A Fireman"), 1944.

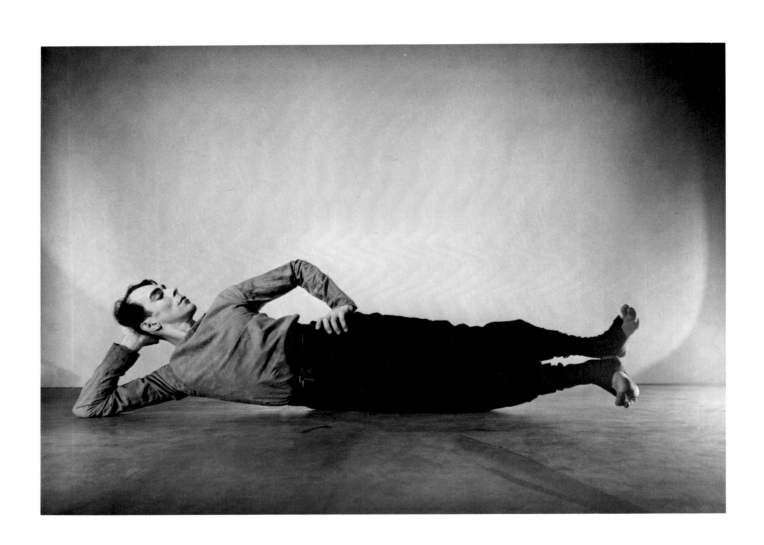

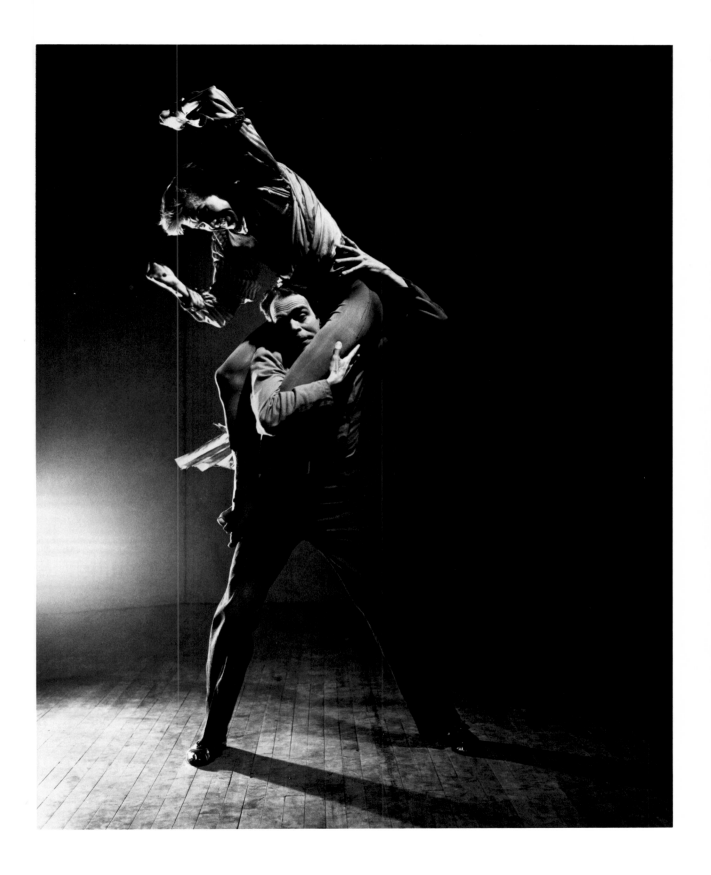

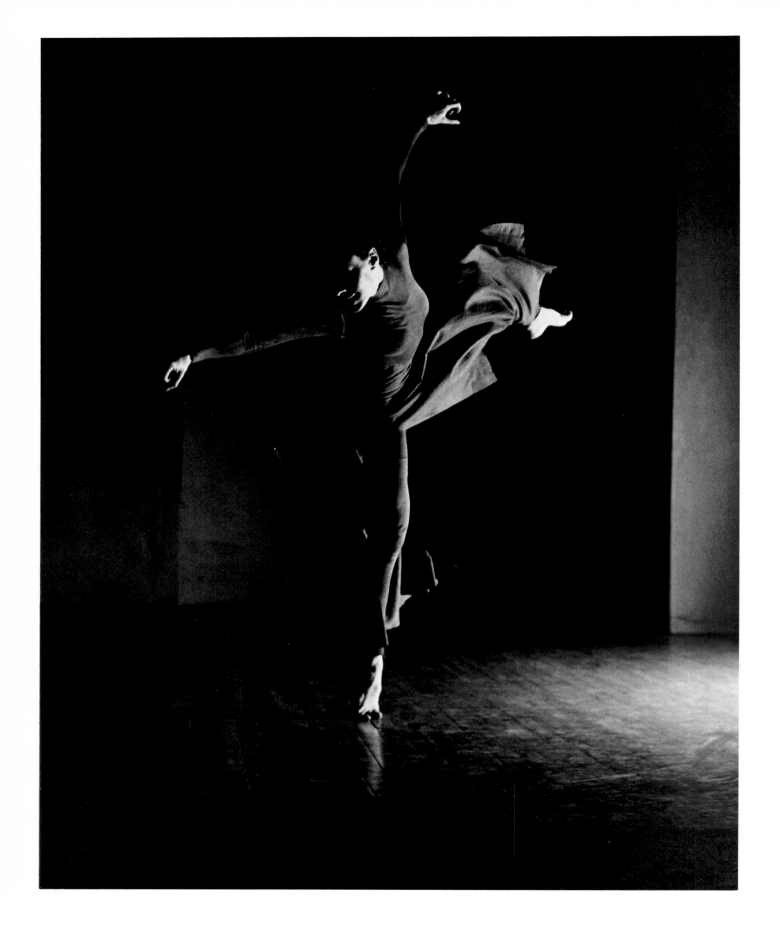

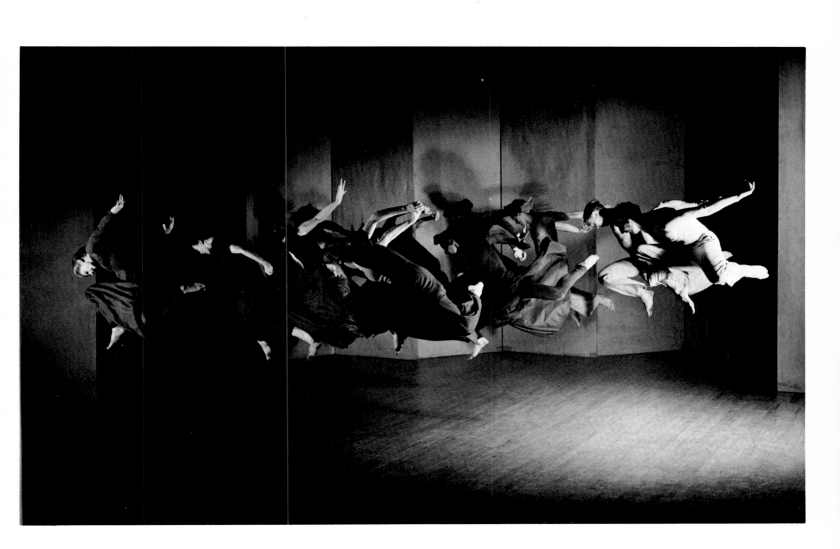

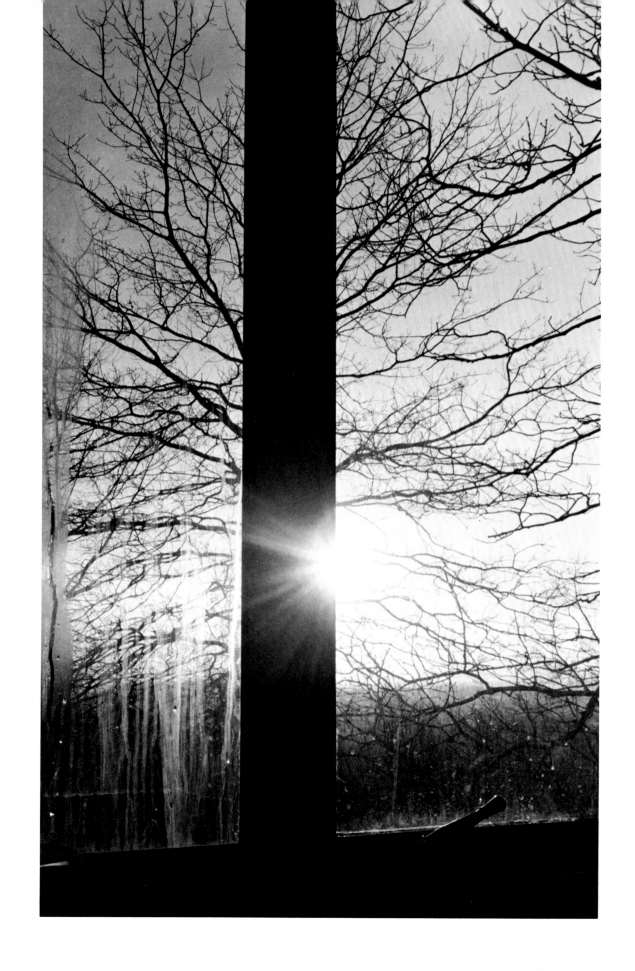

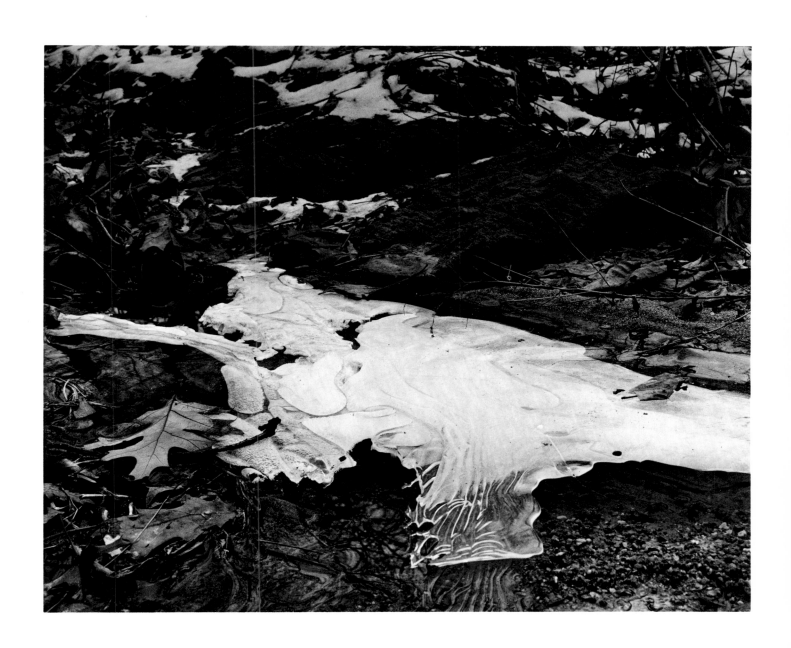

44 DAWN WINDOW, 1945.

45 CONTINUUM, 1944.

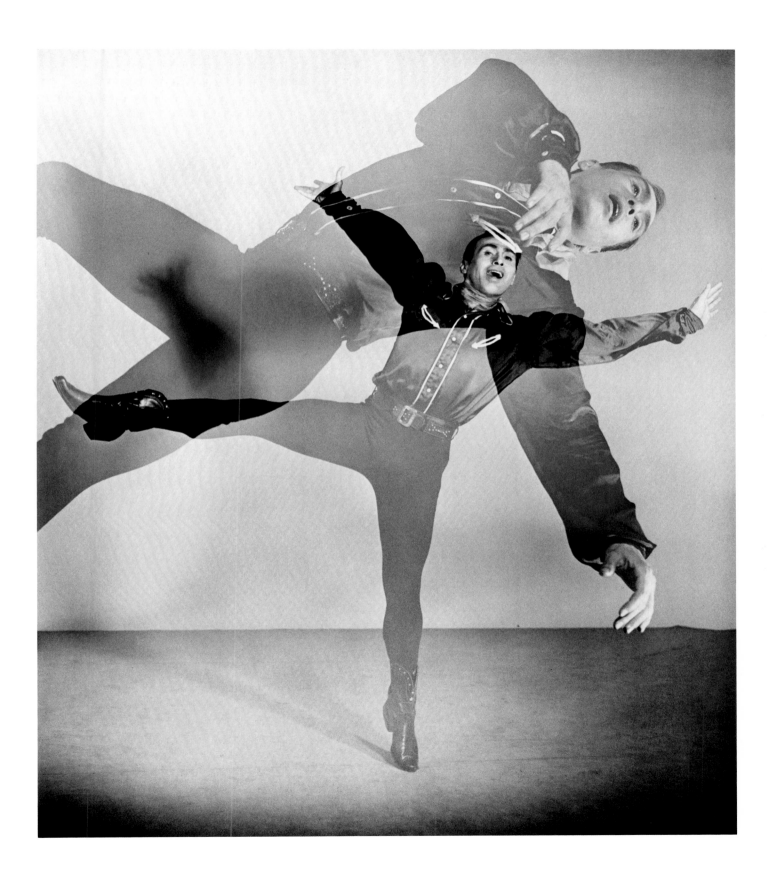

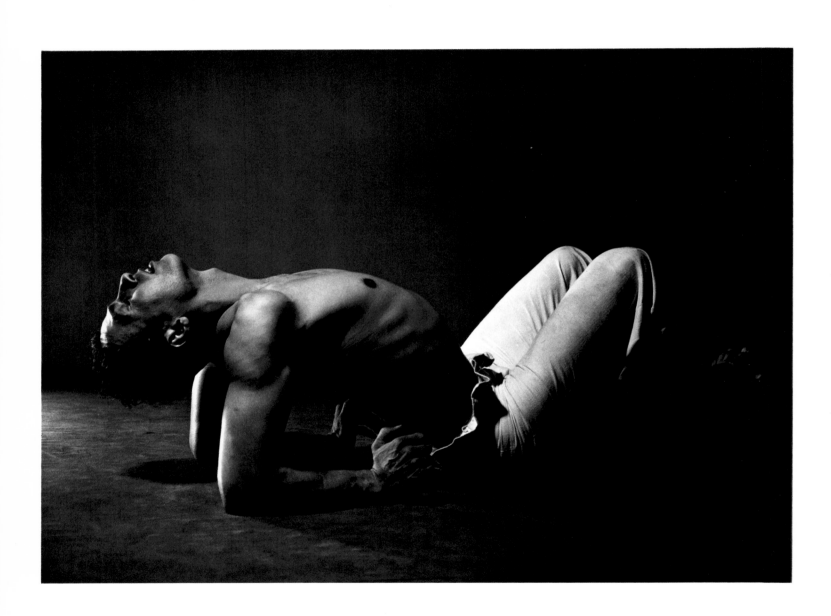

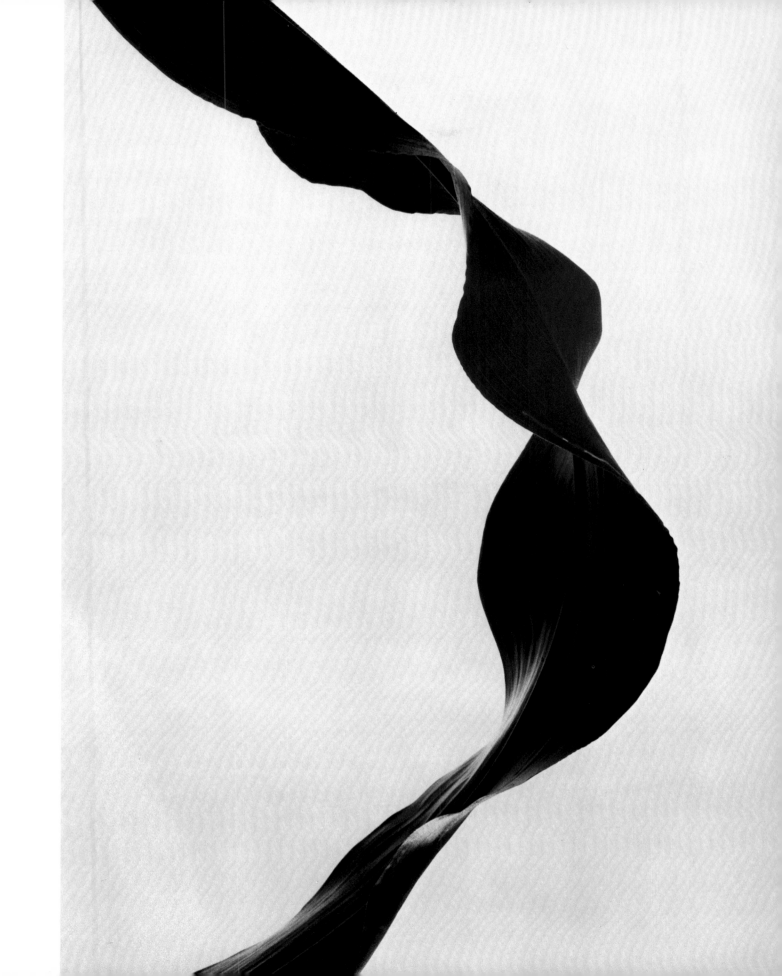

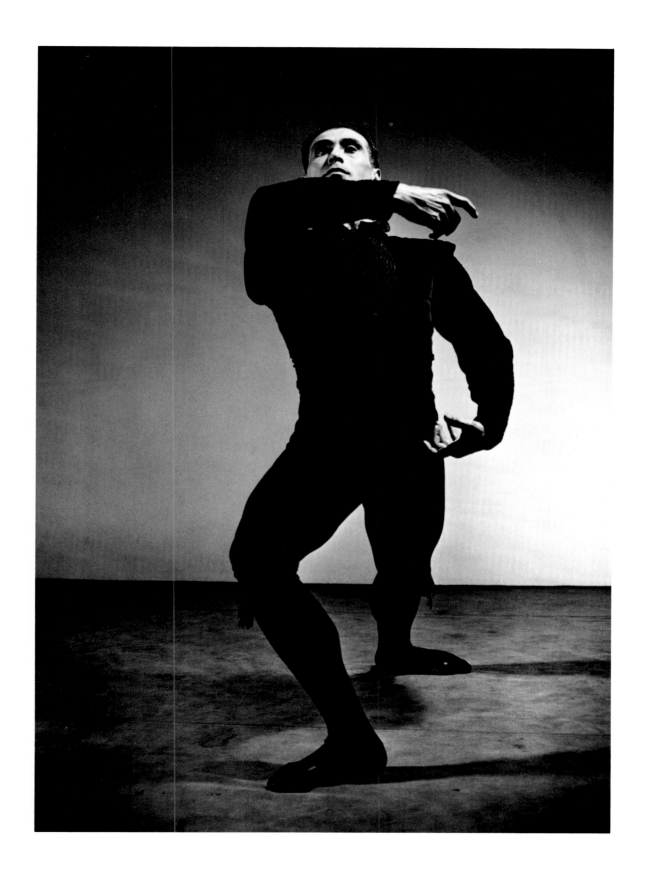

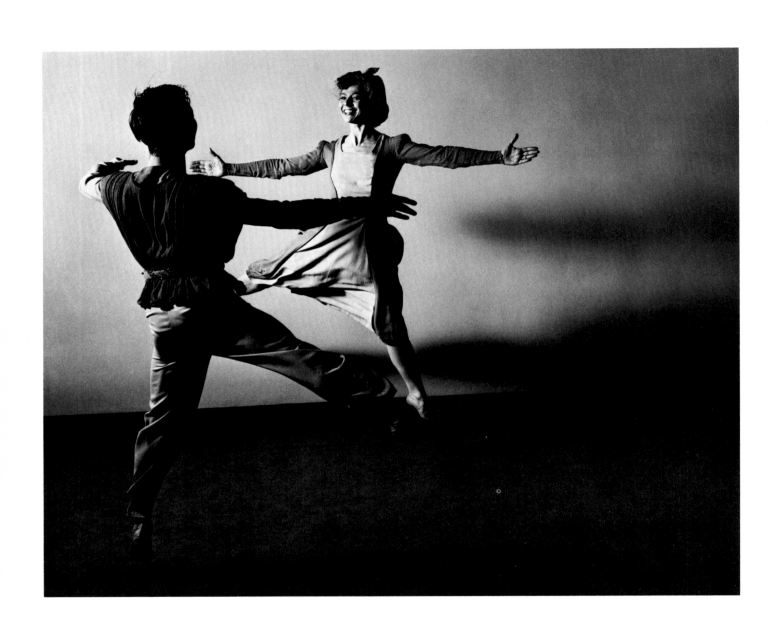

52 Helen Tamaris, "WHEN THE SAINTS COME MARCHIN' IN," (Duet with Daniel Nagrin), 1944.

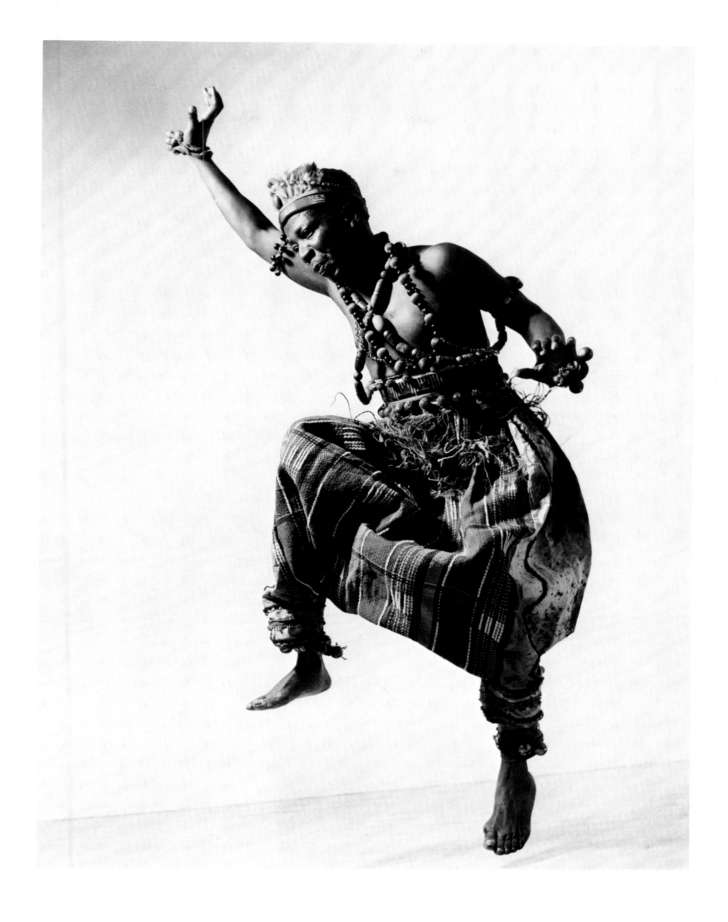

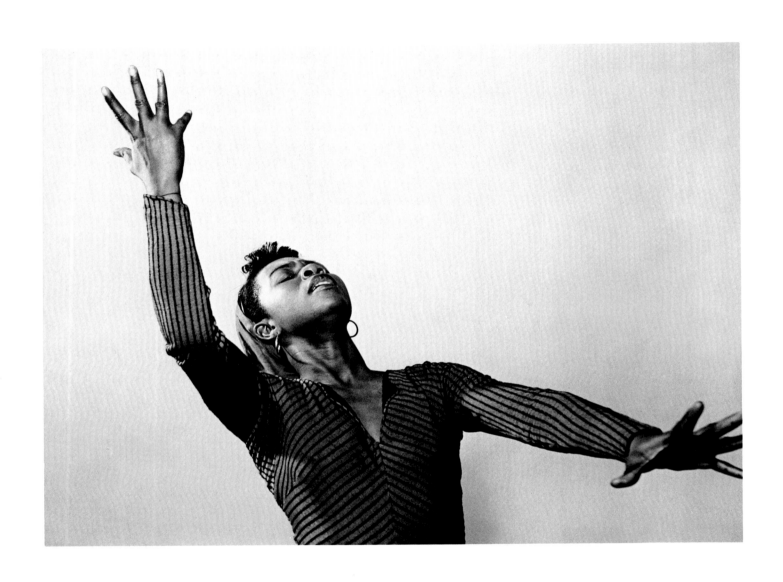

54 Pearl Primus, "SPEAK TO ME OF RIVERS," 1944.

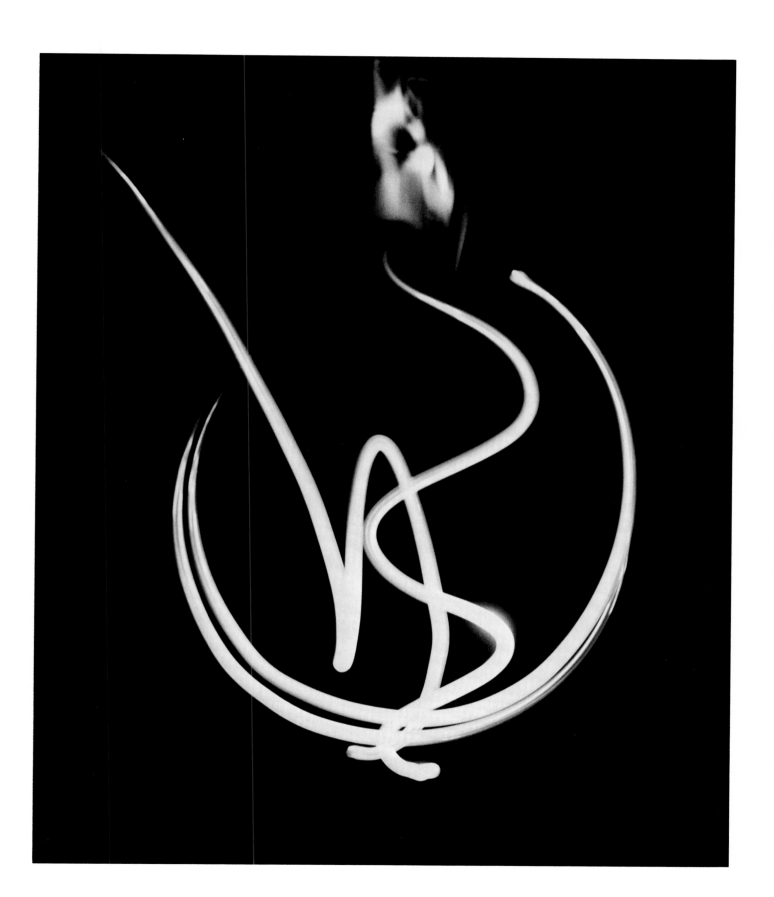

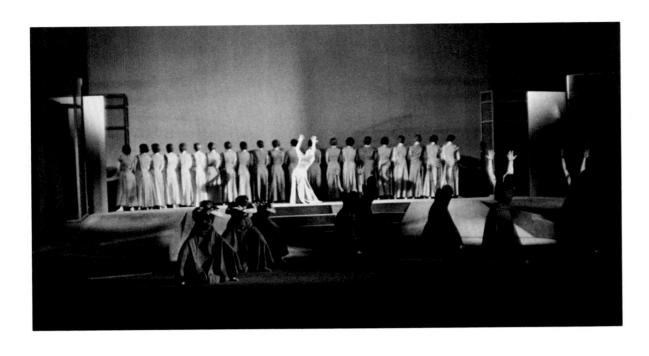

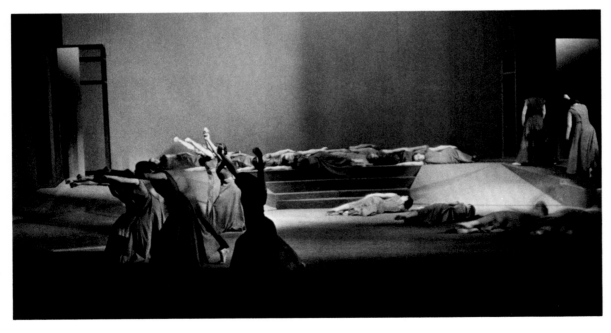

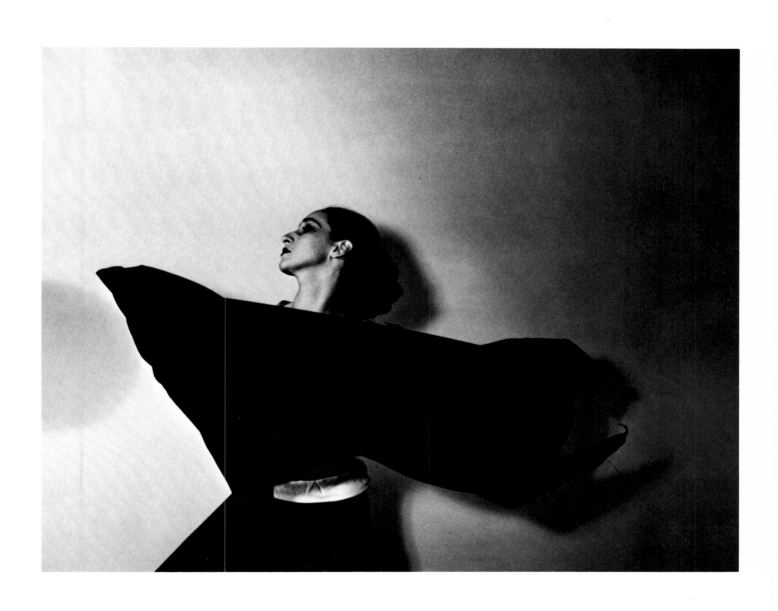

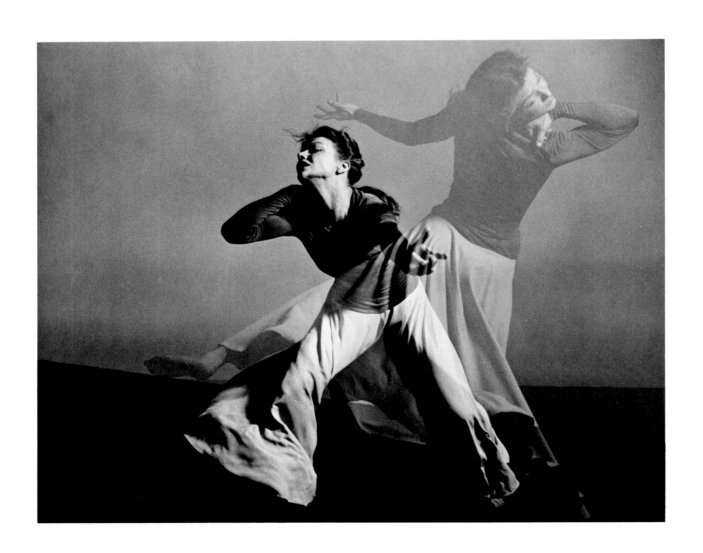

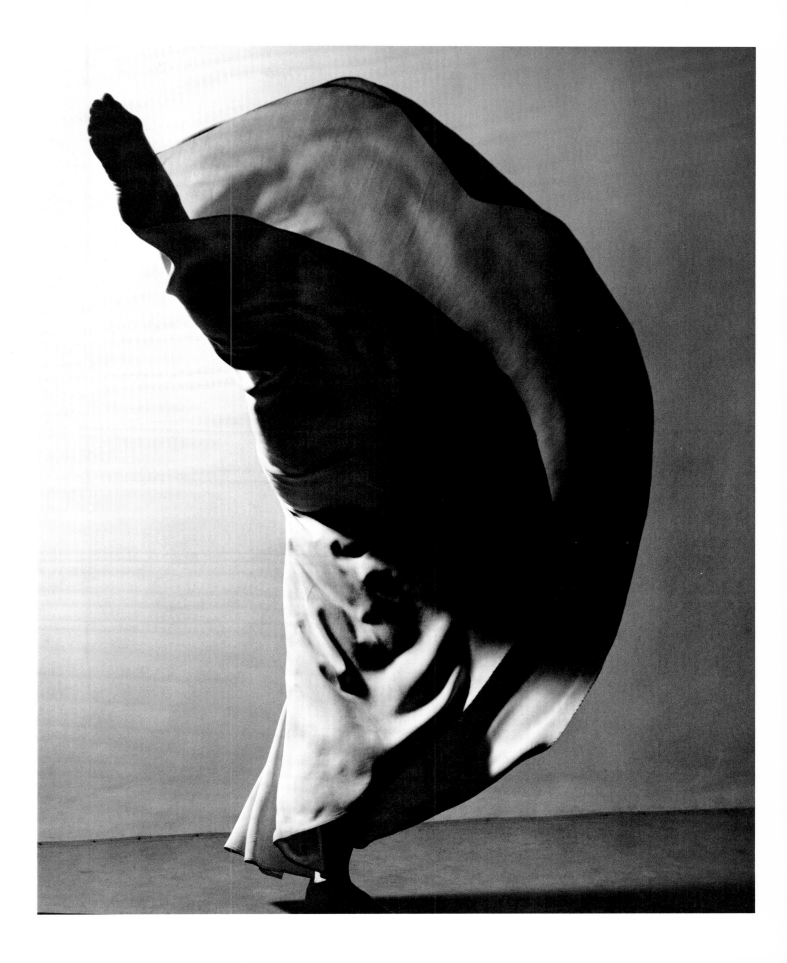

61 Valerie Bettis, DESPERATE HEART, 1944. Photomontage II

62 Merce Cunningham, TOTEM ANCESTOR, 1942.

63 Merce Cunningham, ROOT OF THE UNFOCUS, 1944. Photomontage

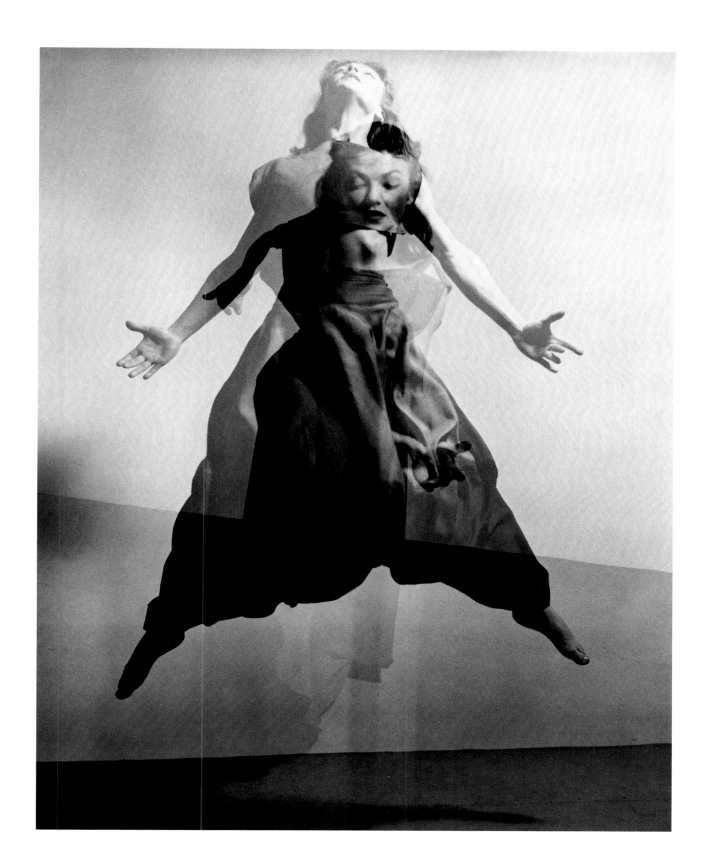

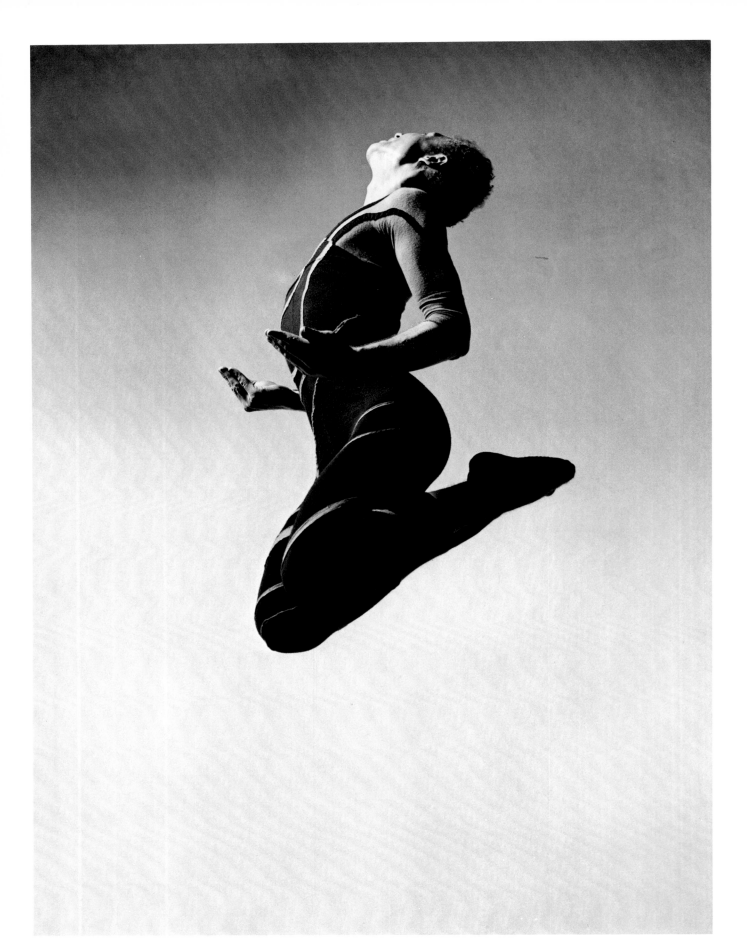

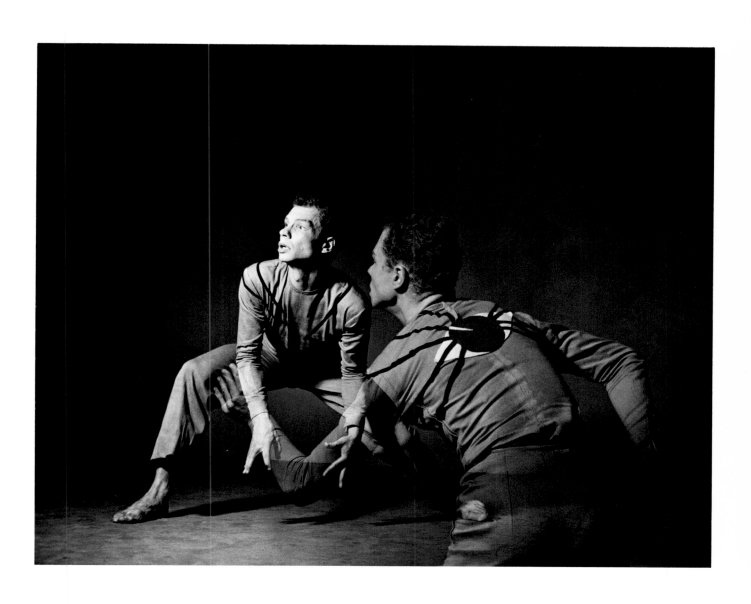

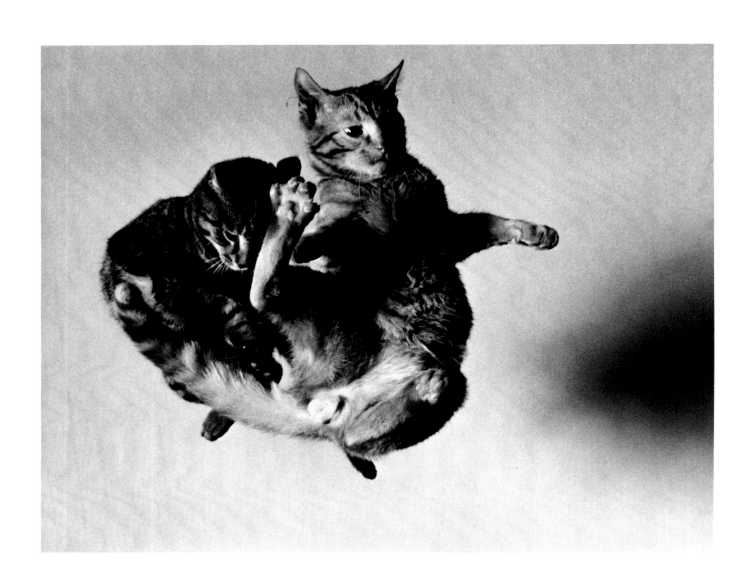

66 TOSSED CATS, 1942.
67 ERICK HAWKINS JUMPING WITH LLOYD, 1942.

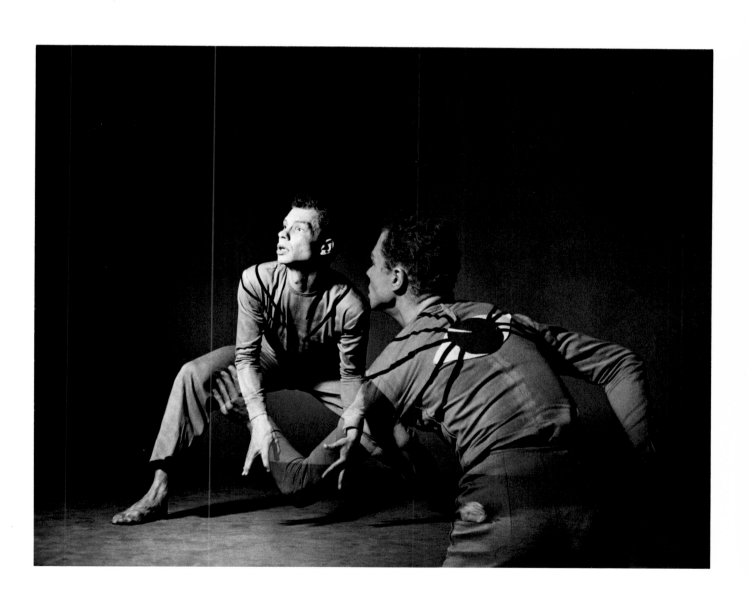

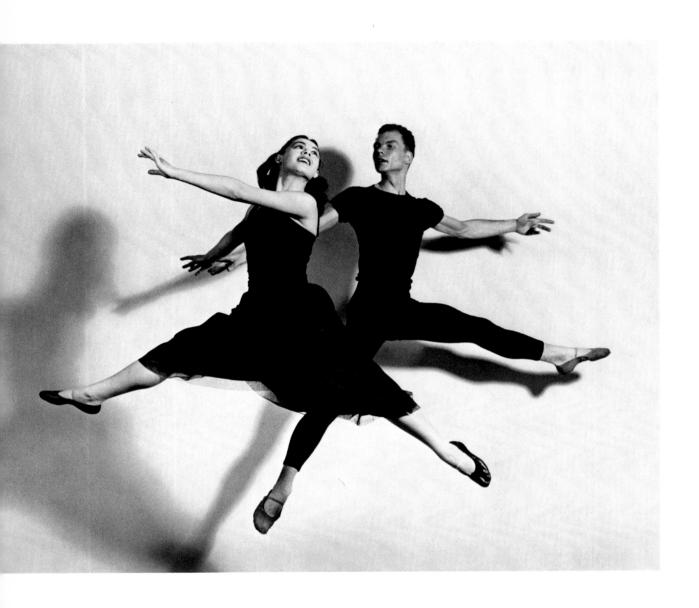

64 Merce Cunningham and Pearl Lang, LEAP, 1942.
65 Merce Cunningham, LEAP, 1942.

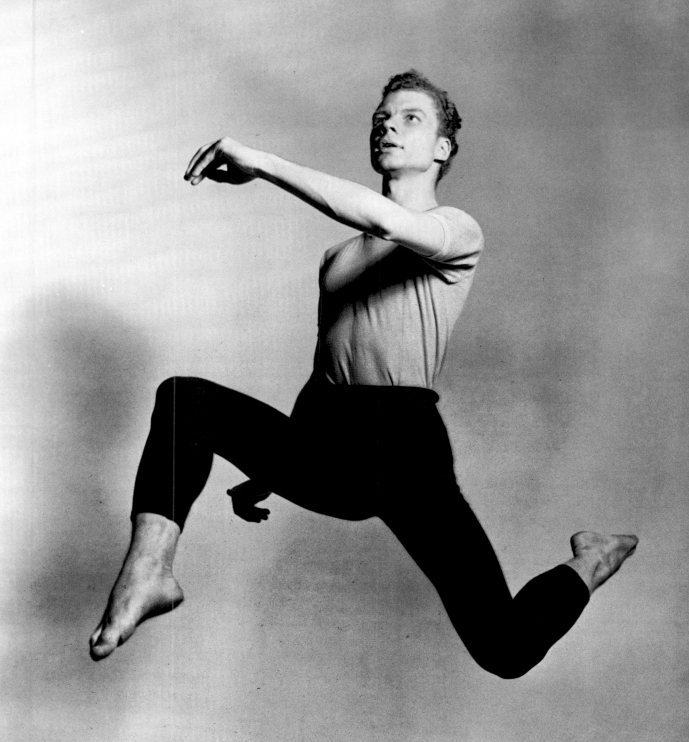

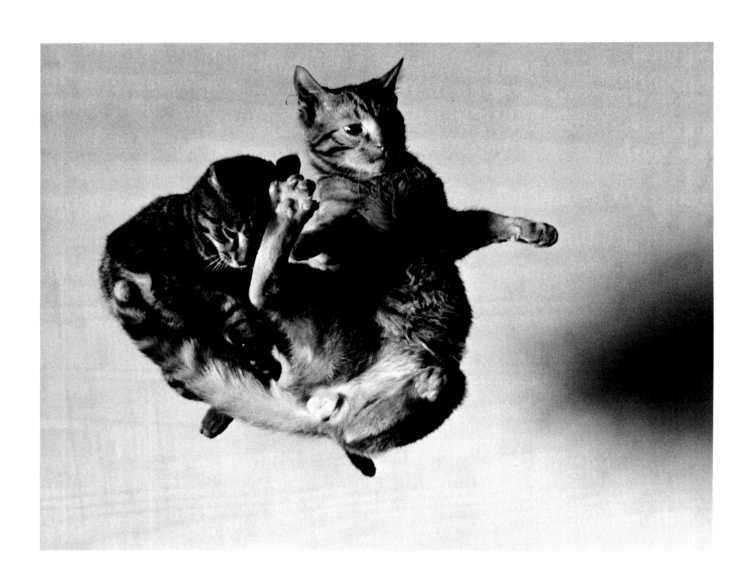

66 TOSSED CATS, 1942.
67 ERICK HAWKINS JUMPING WITH LLOYD, 1942.

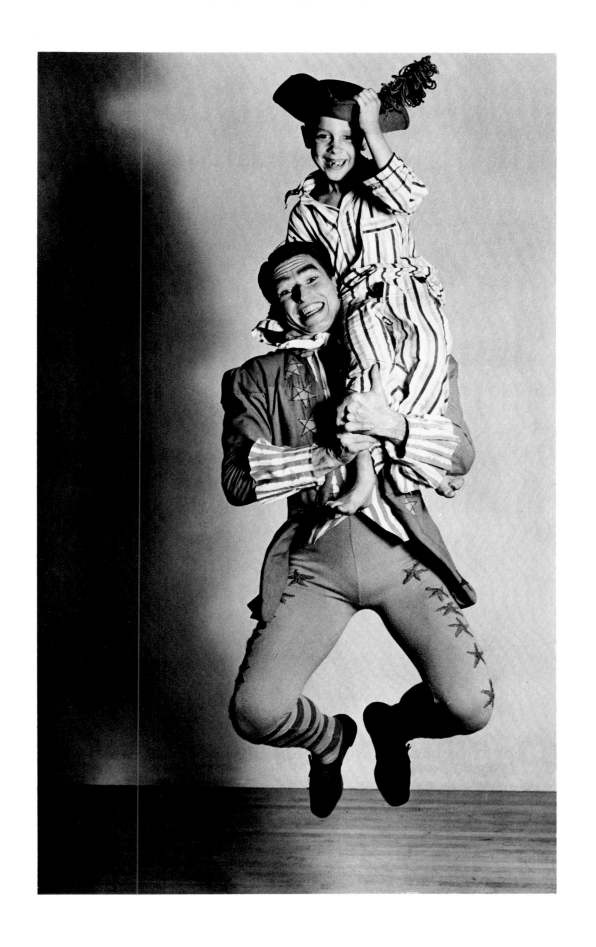

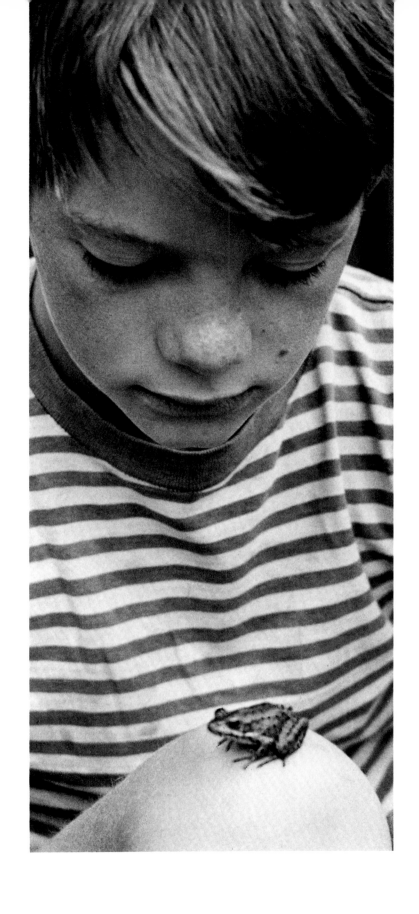

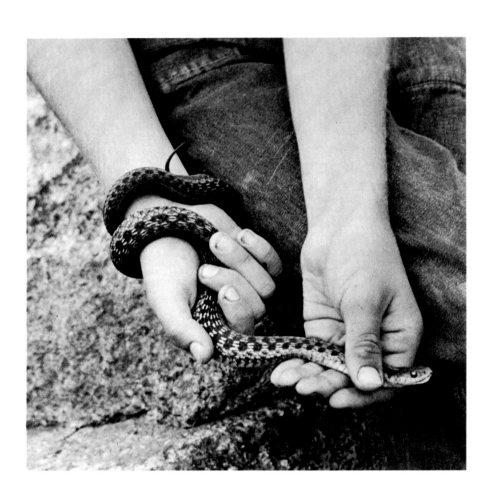

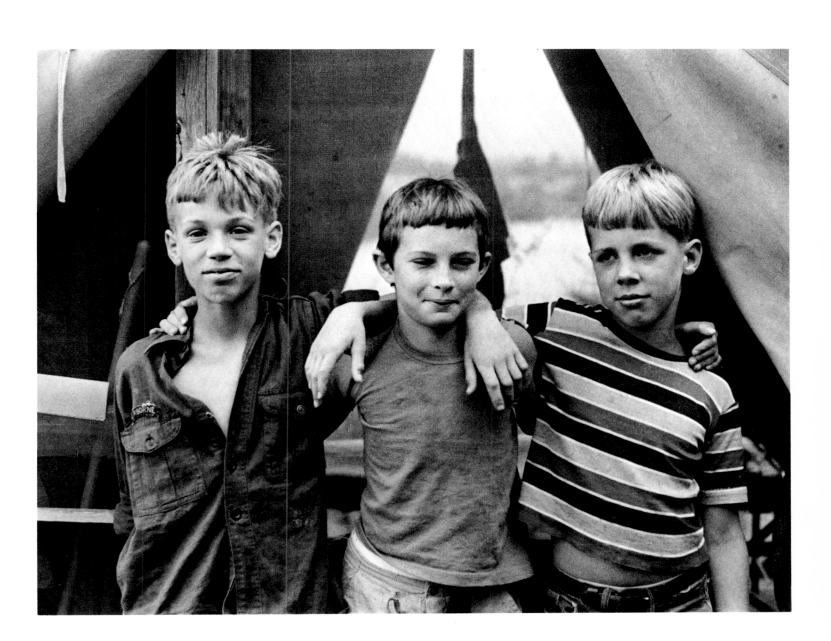

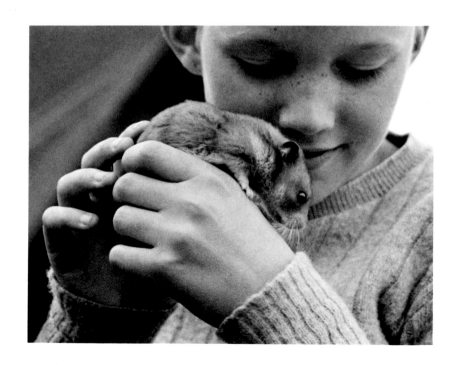

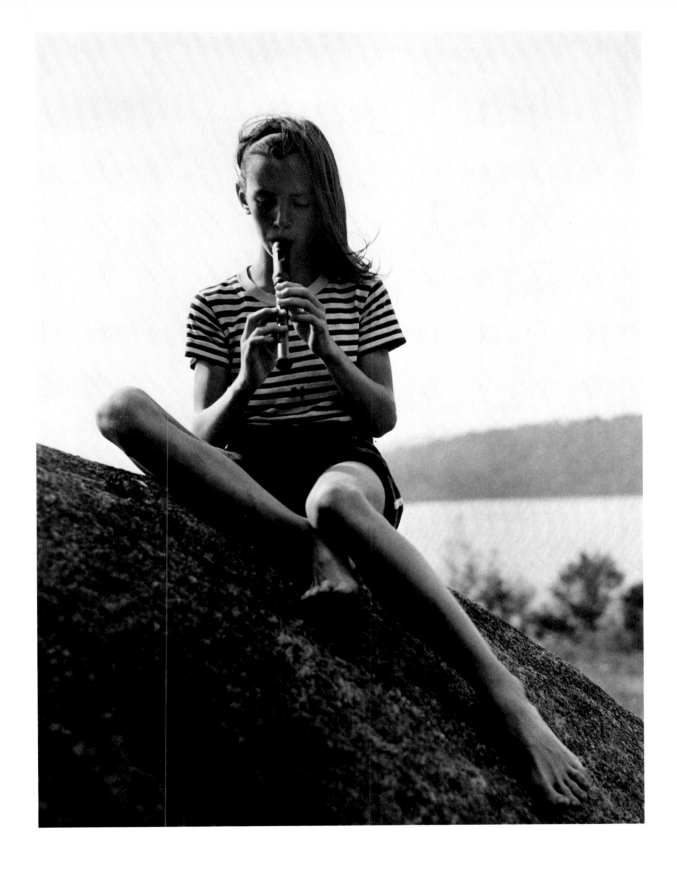

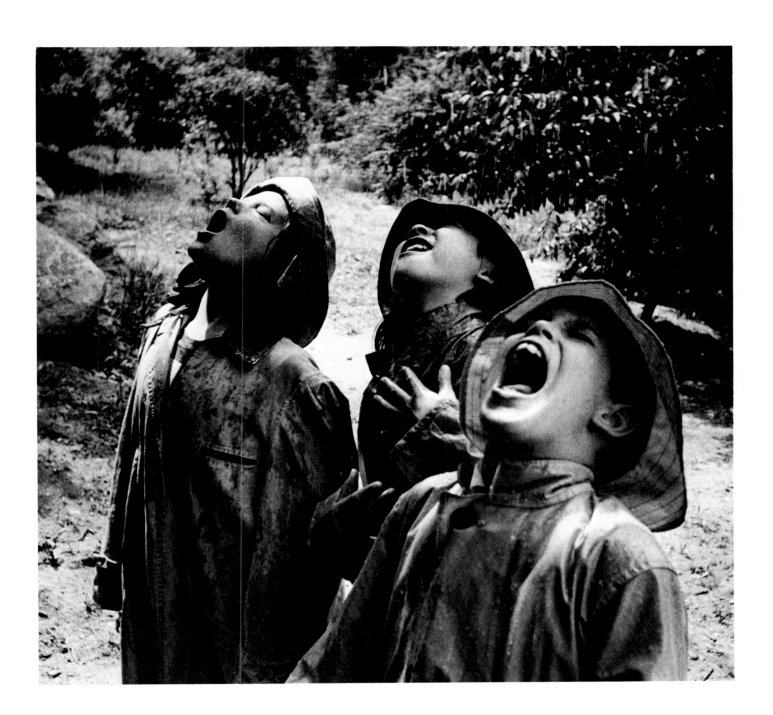

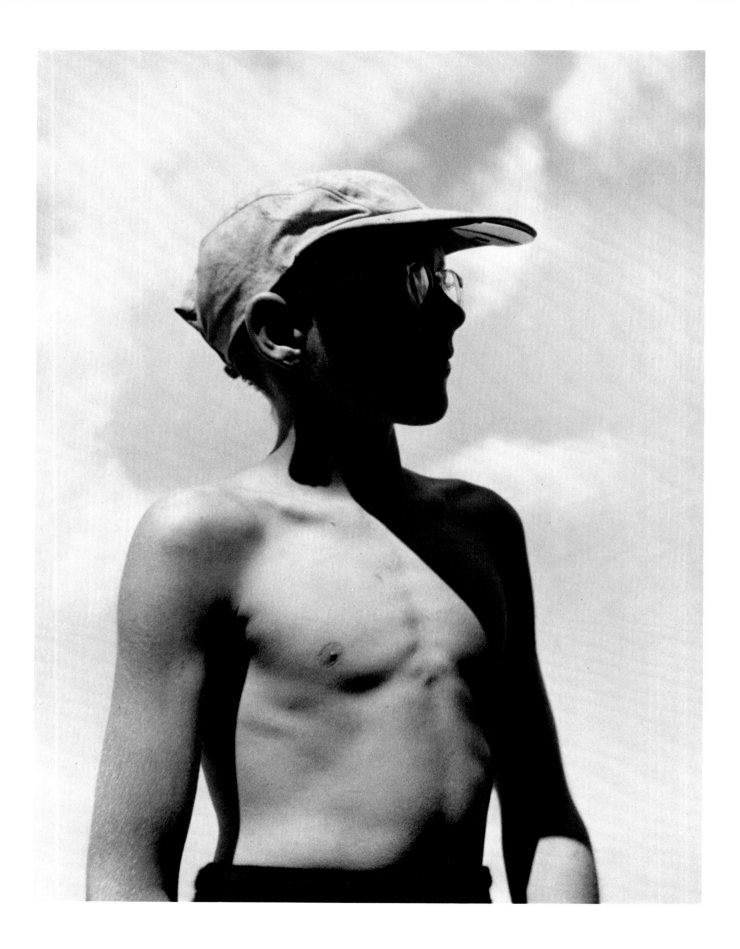

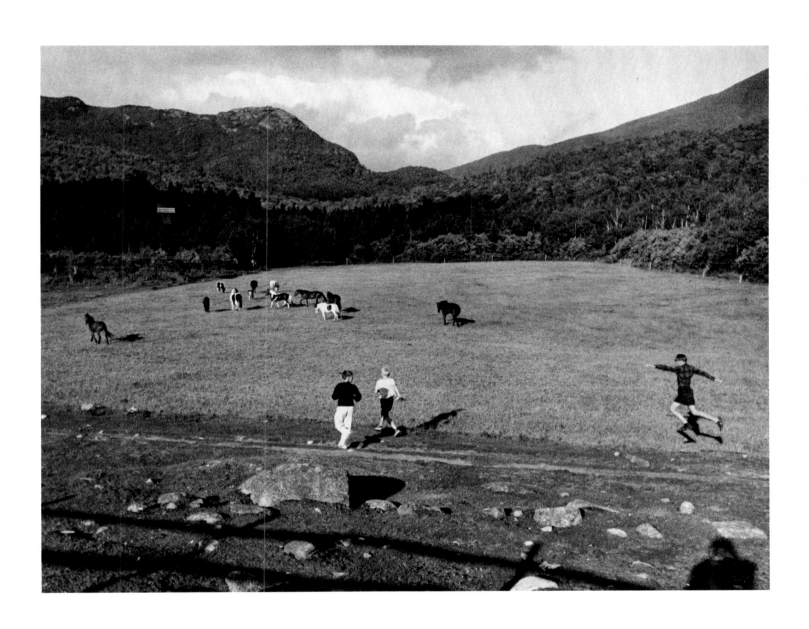

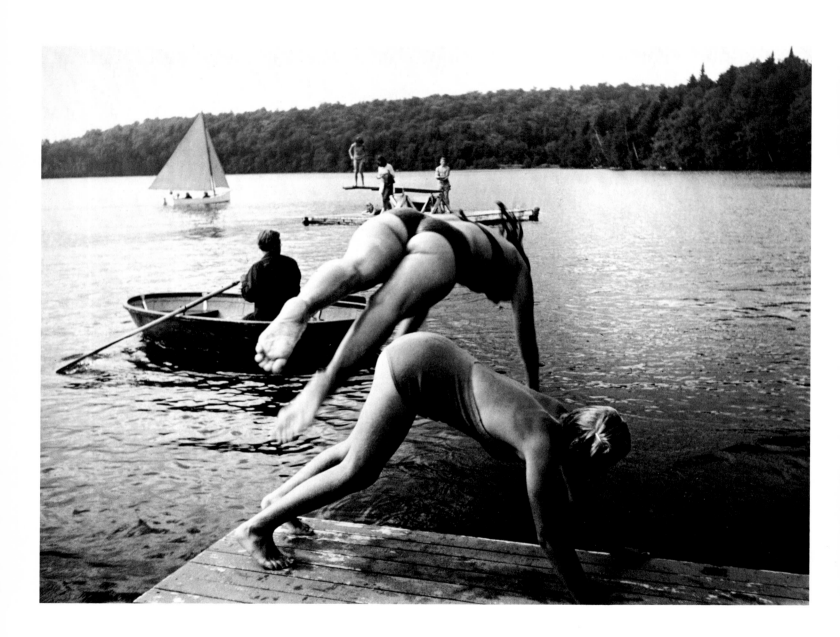

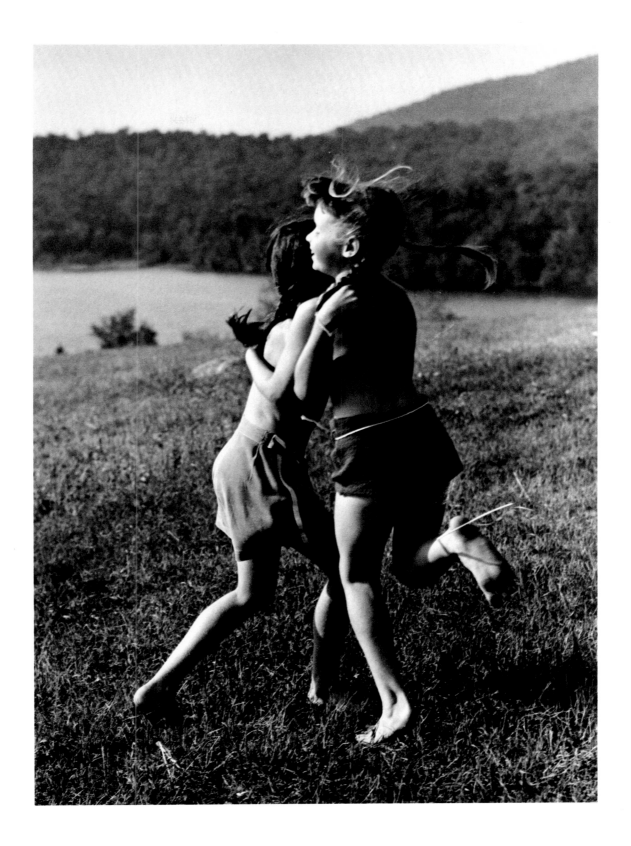

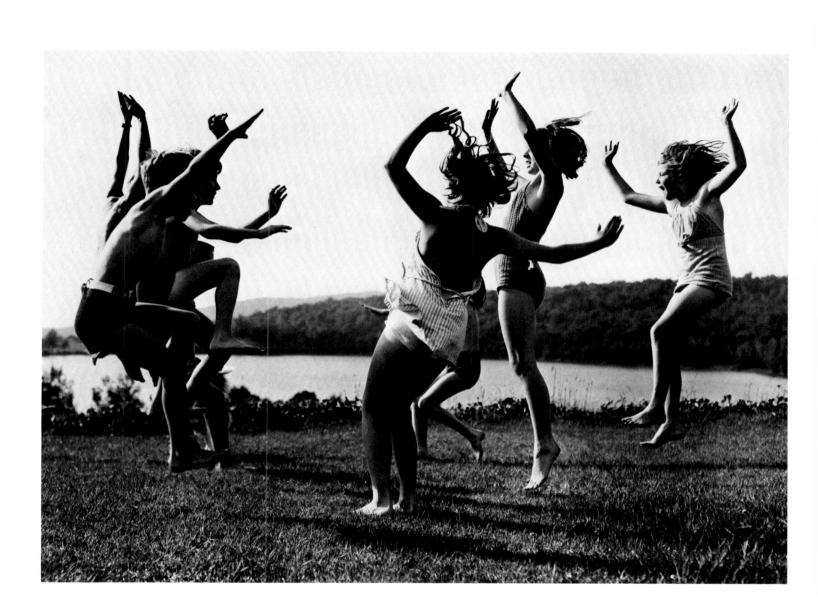

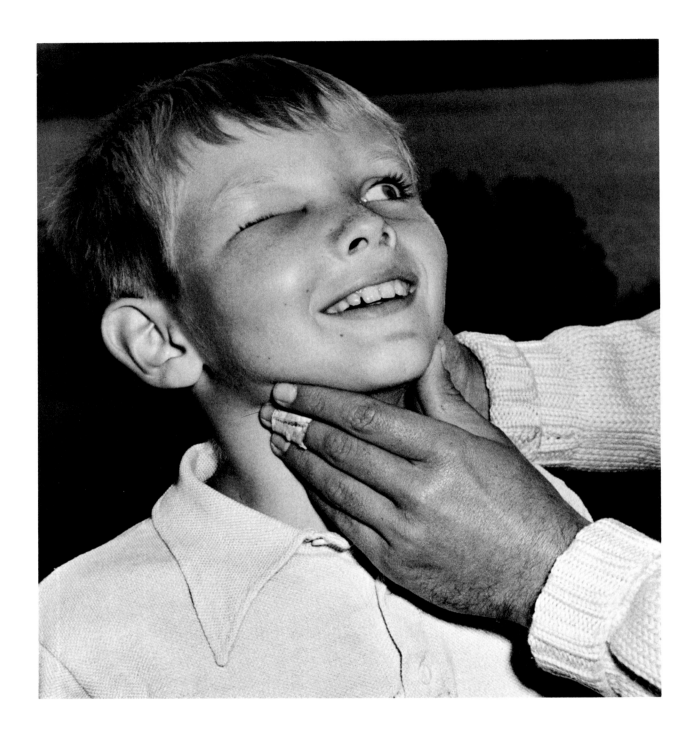

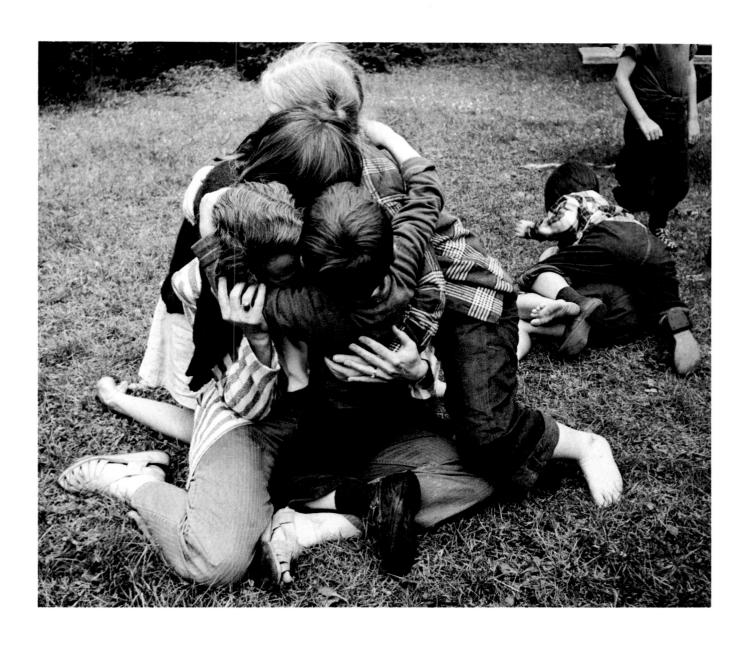

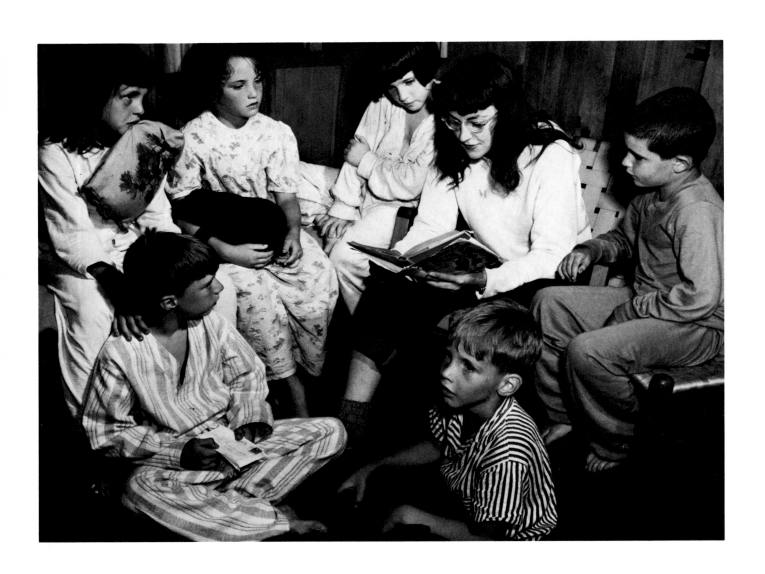

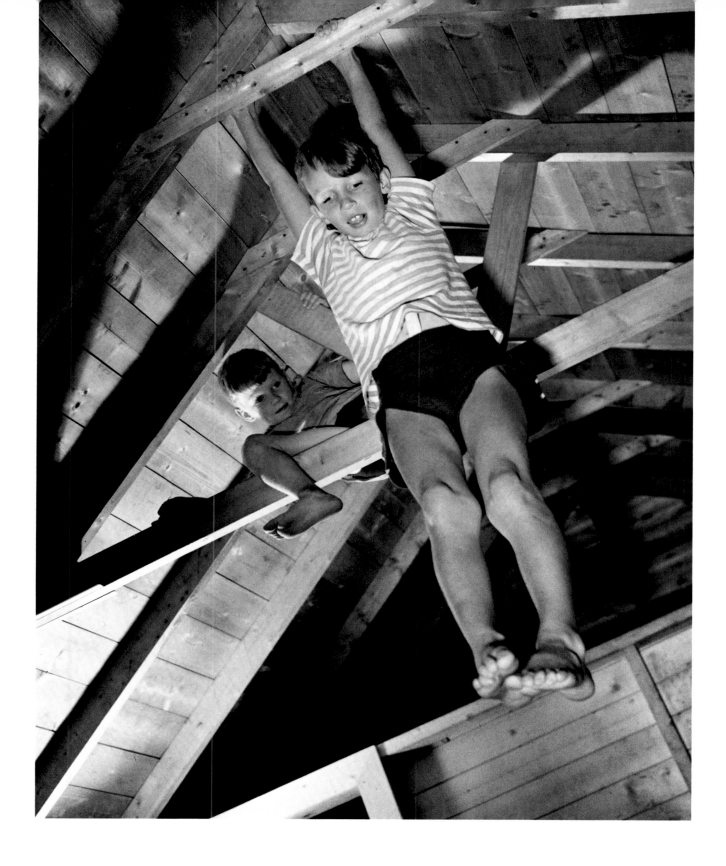

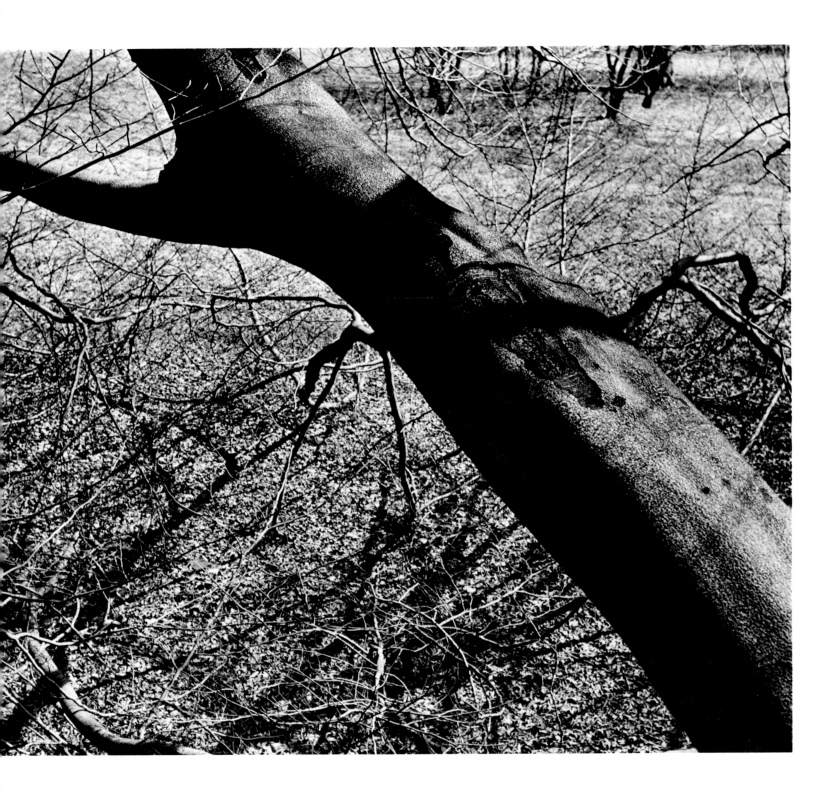

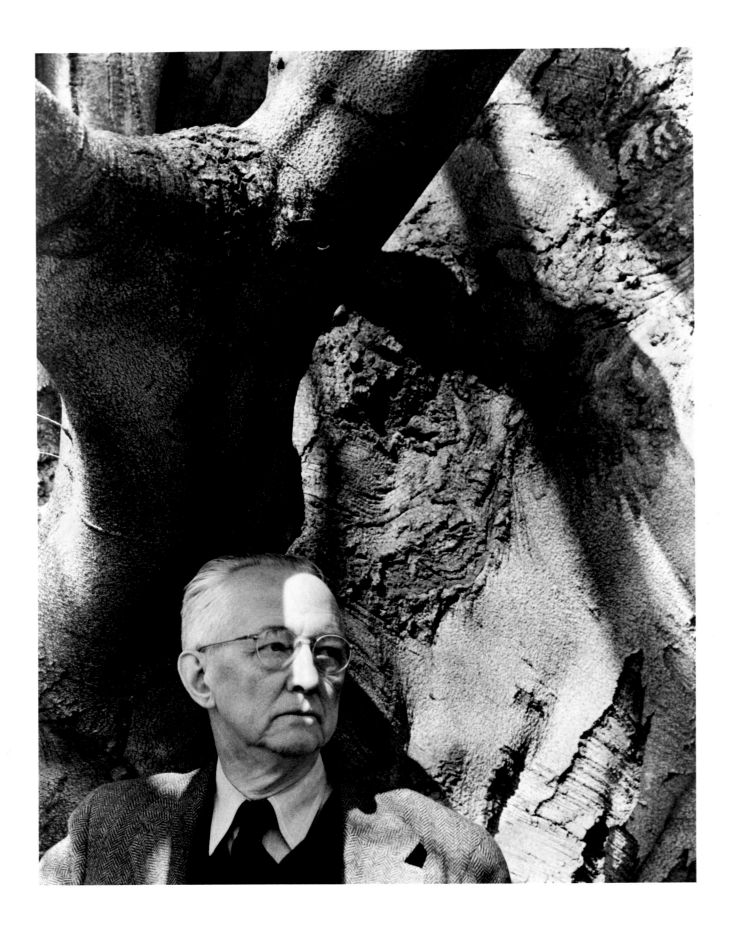

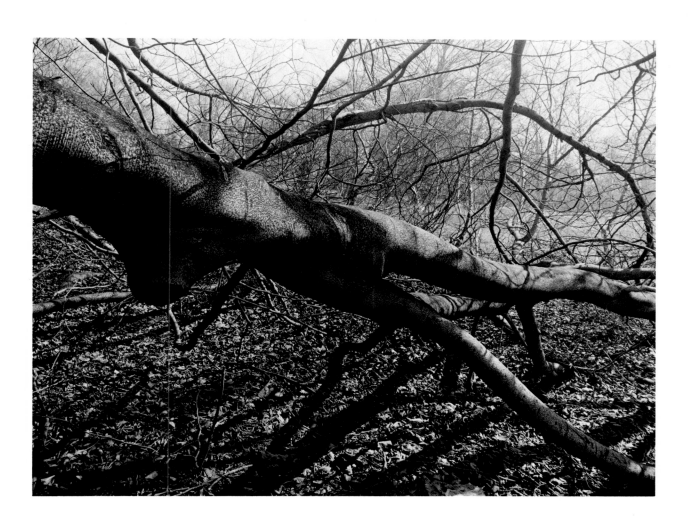

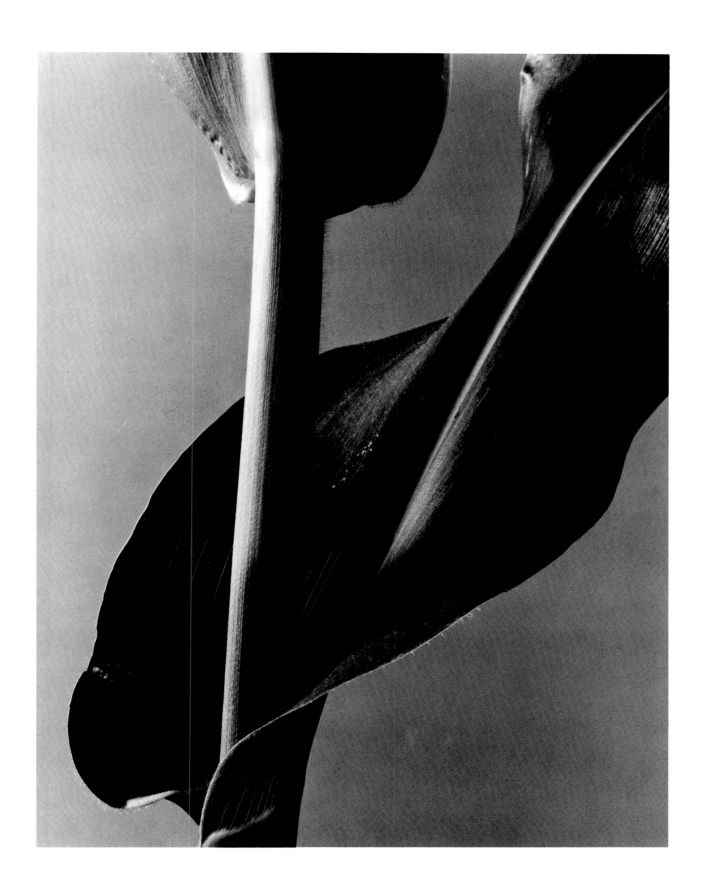

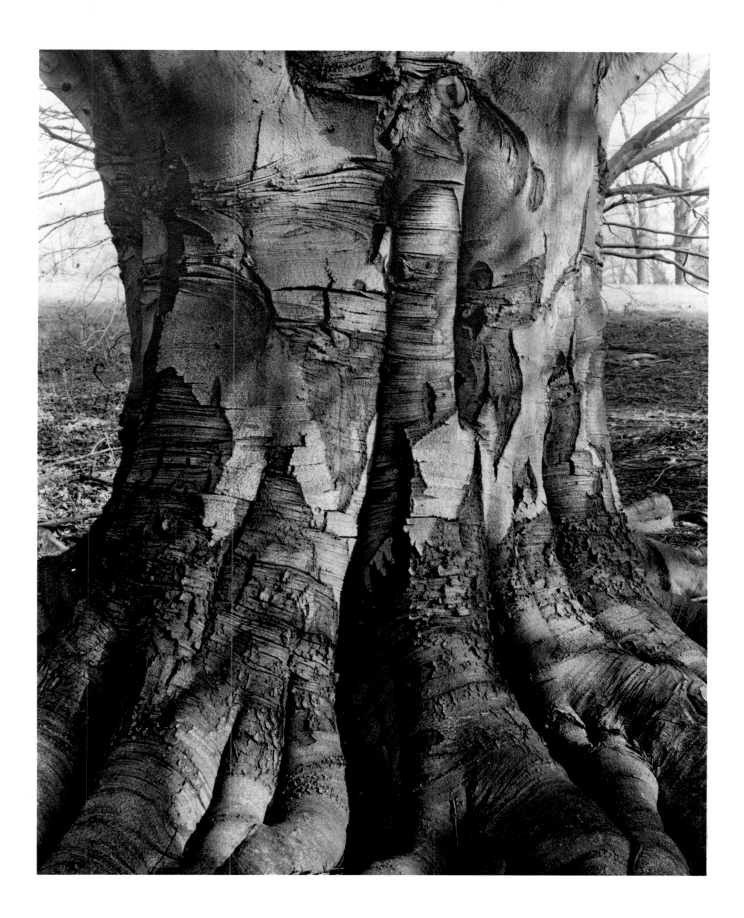

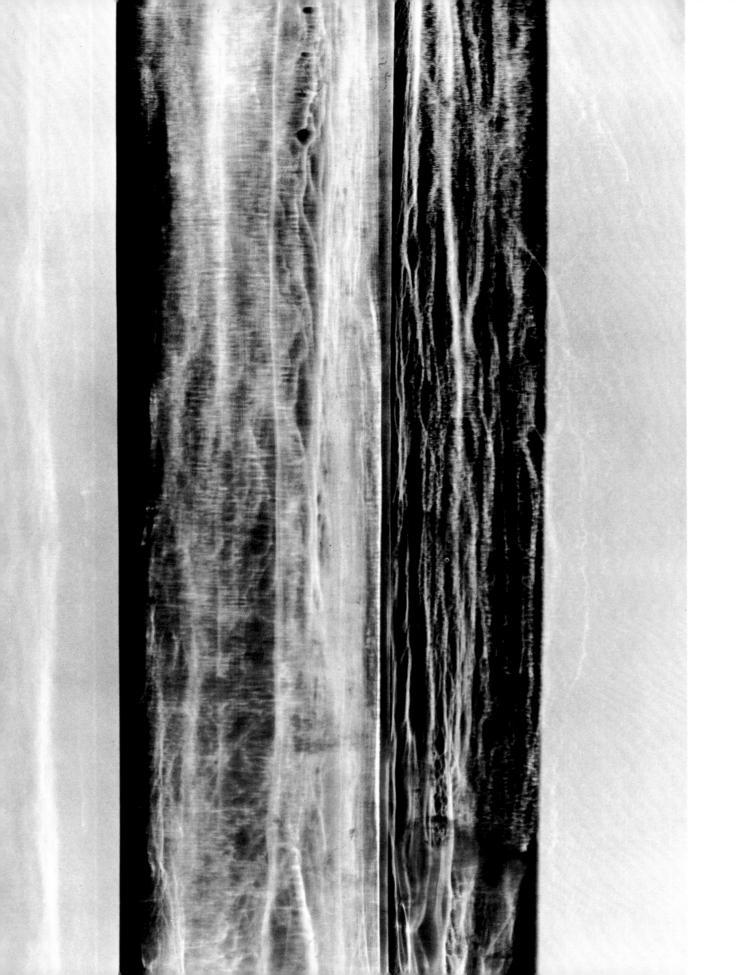

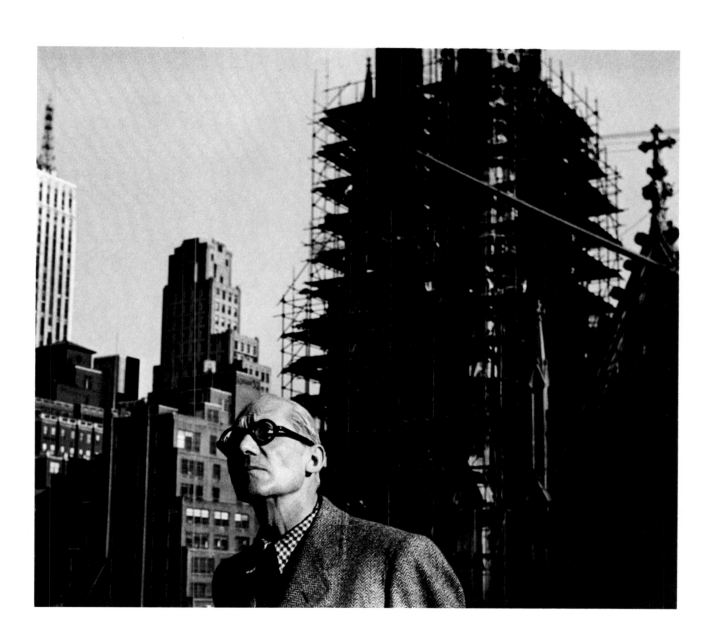

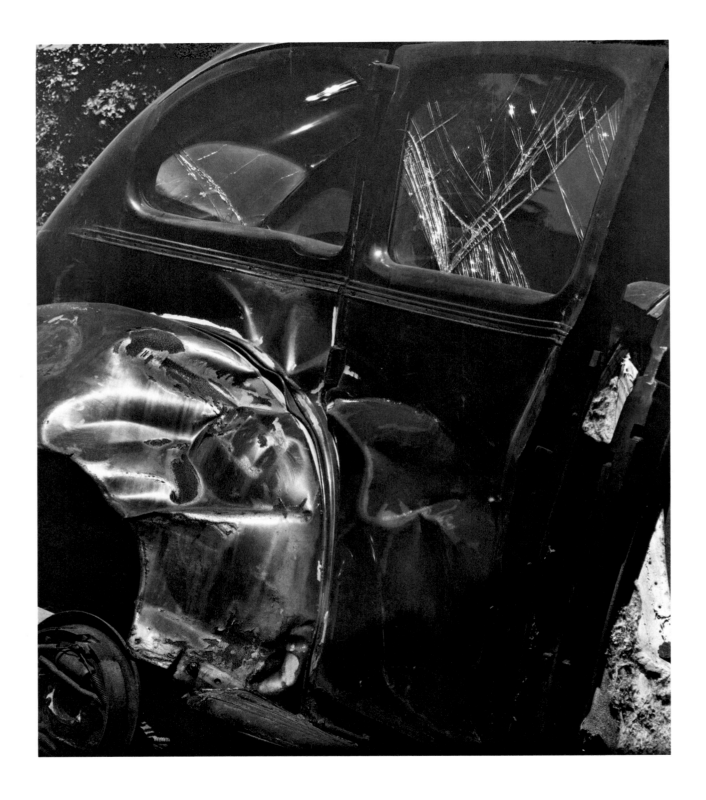

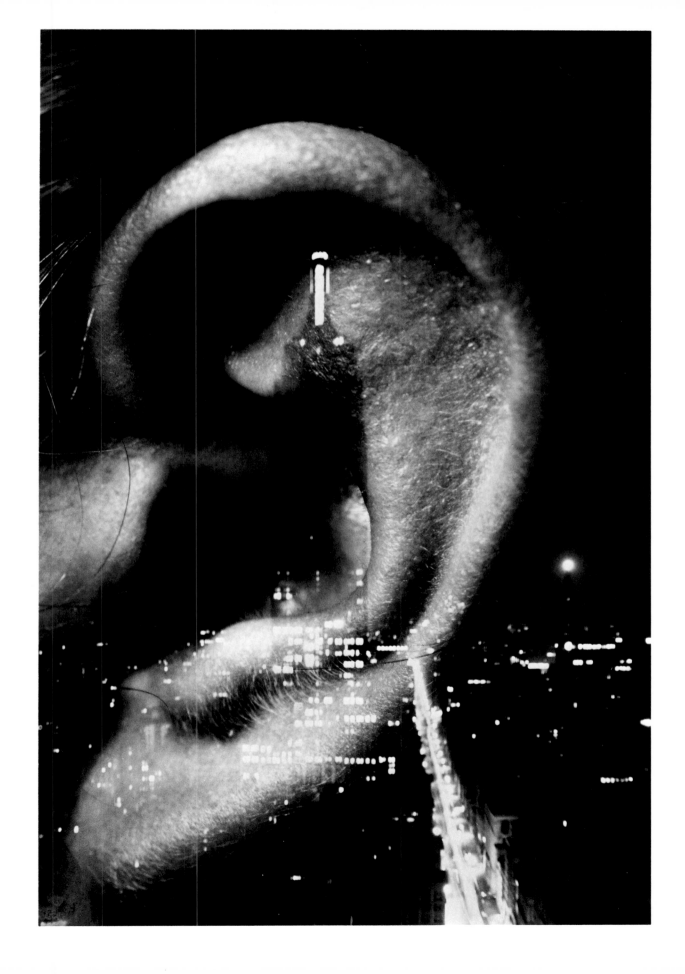

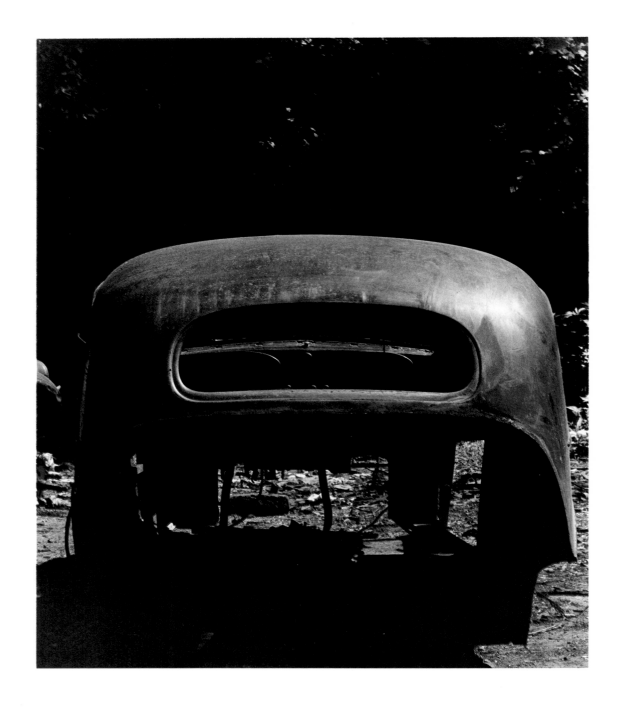

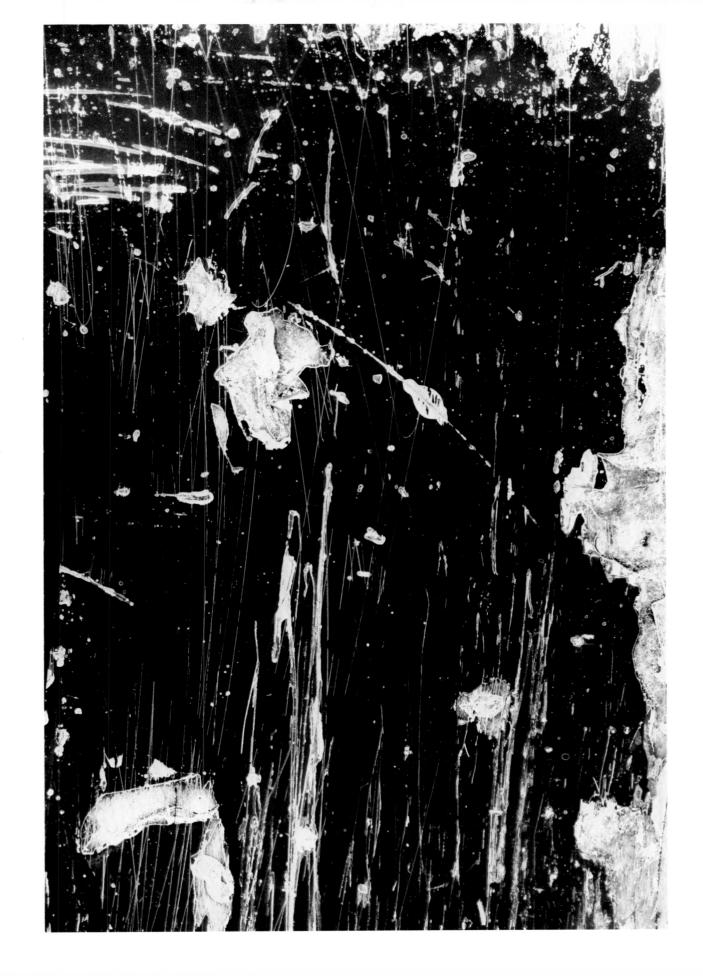

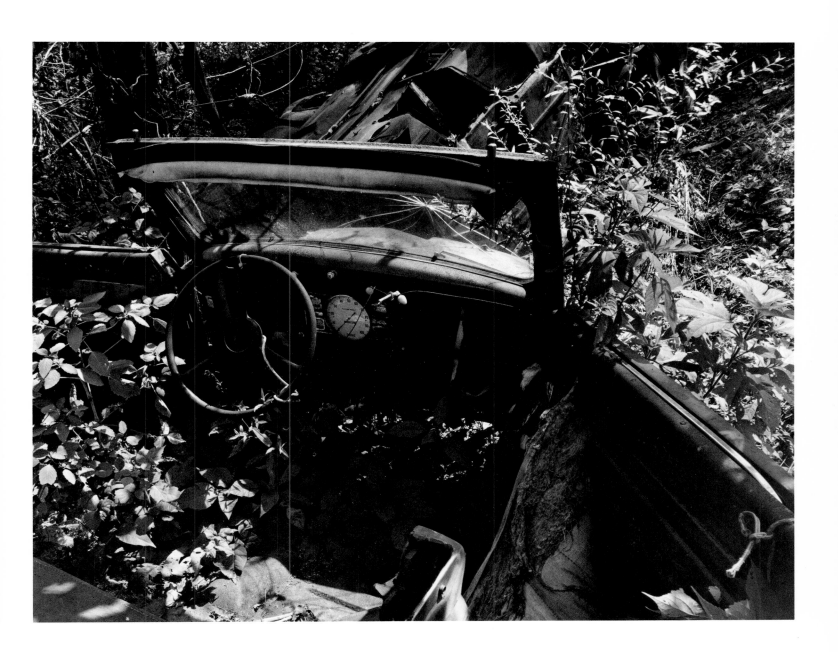

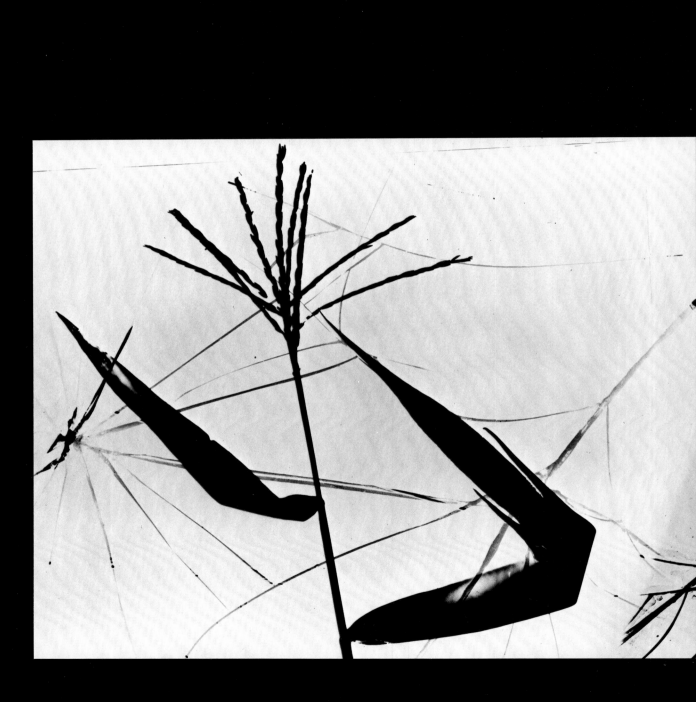

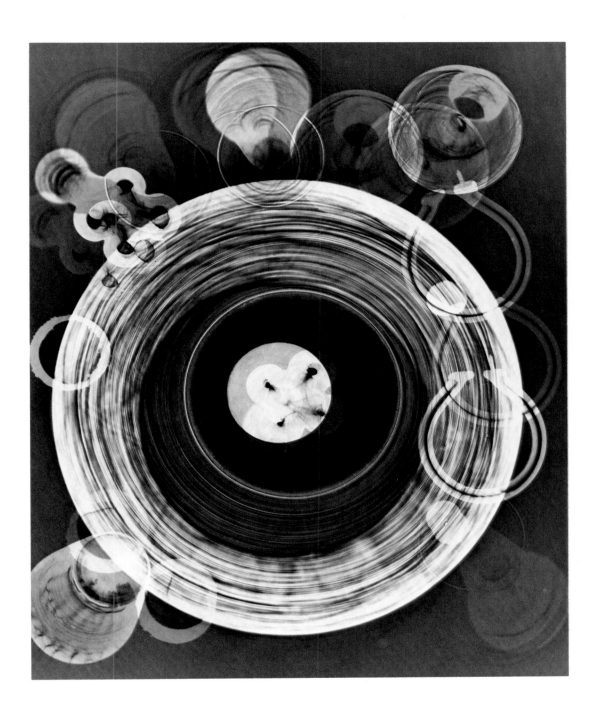

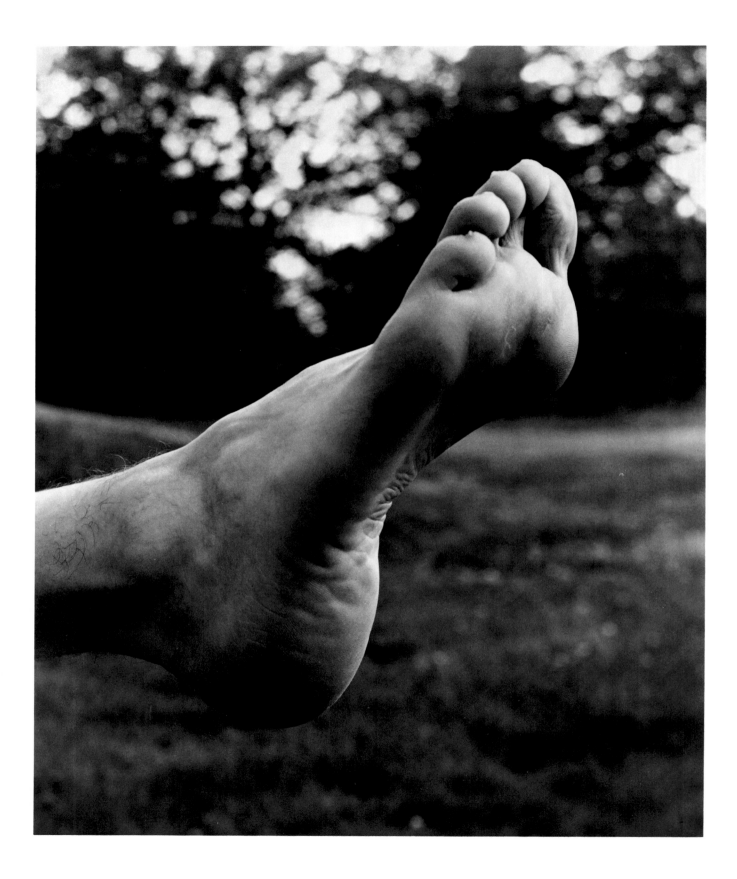

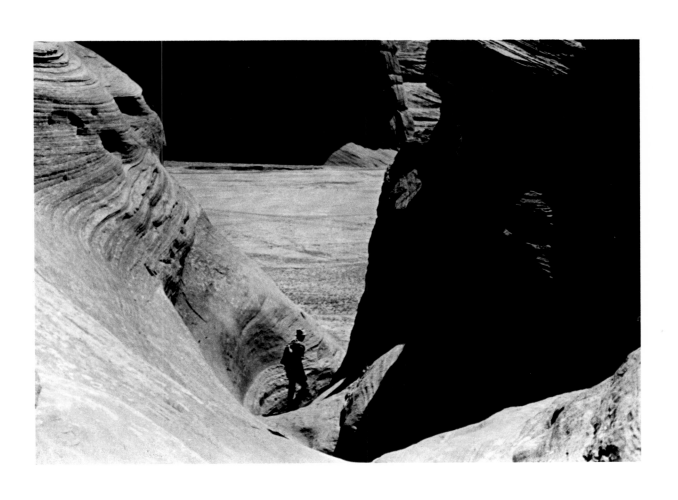

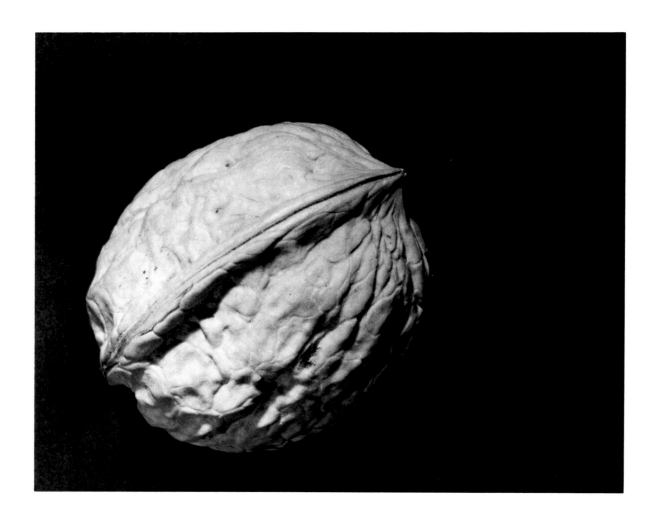

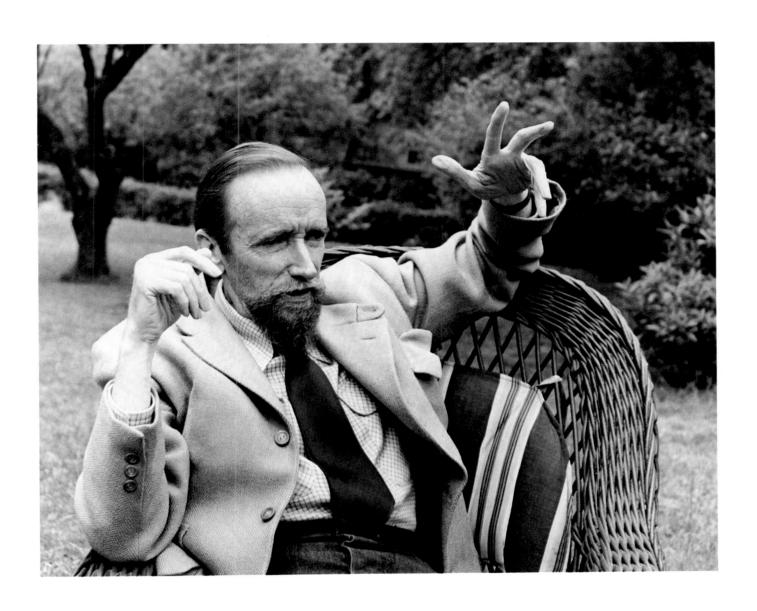

106 WALNUT, 1943.
107 GERALD HEARD, 1954.

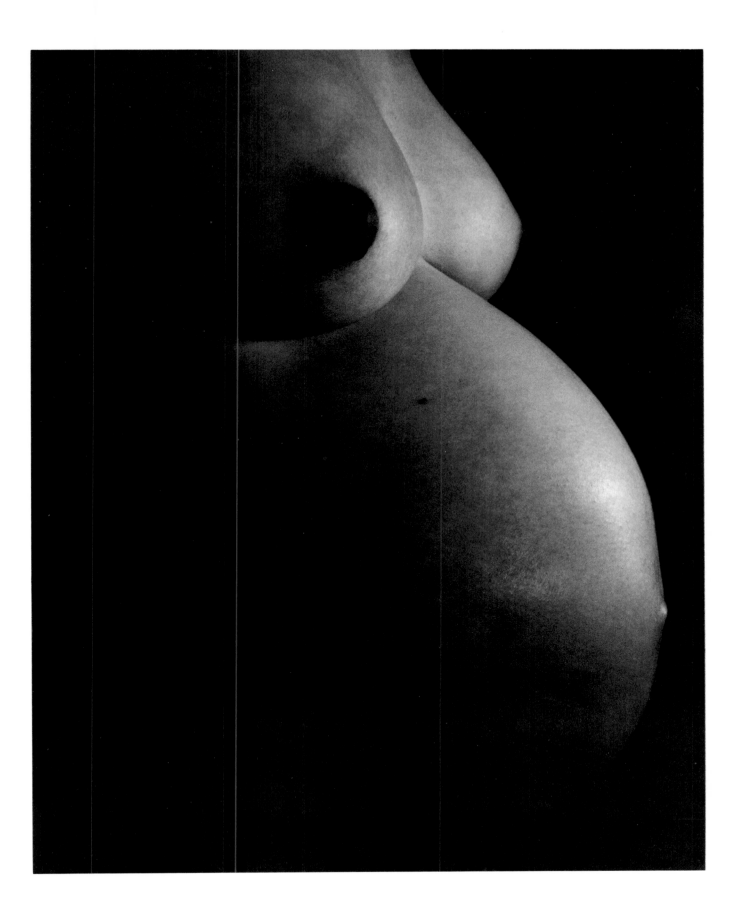

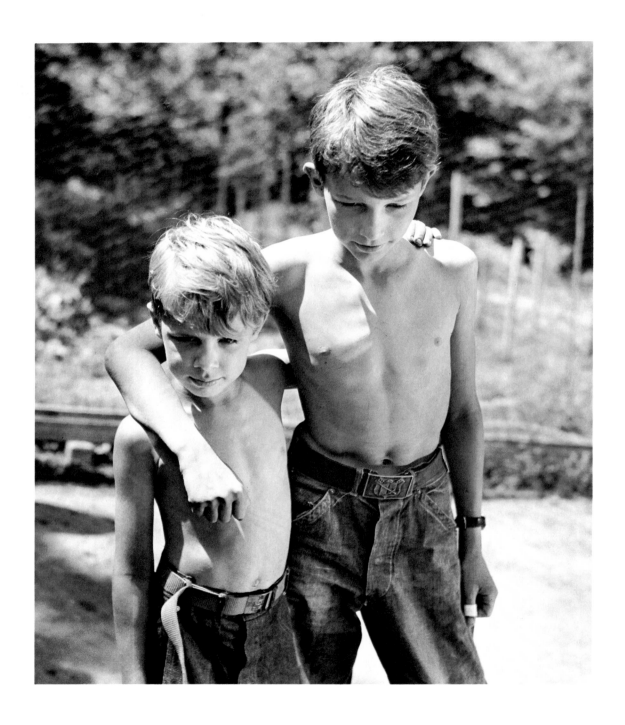

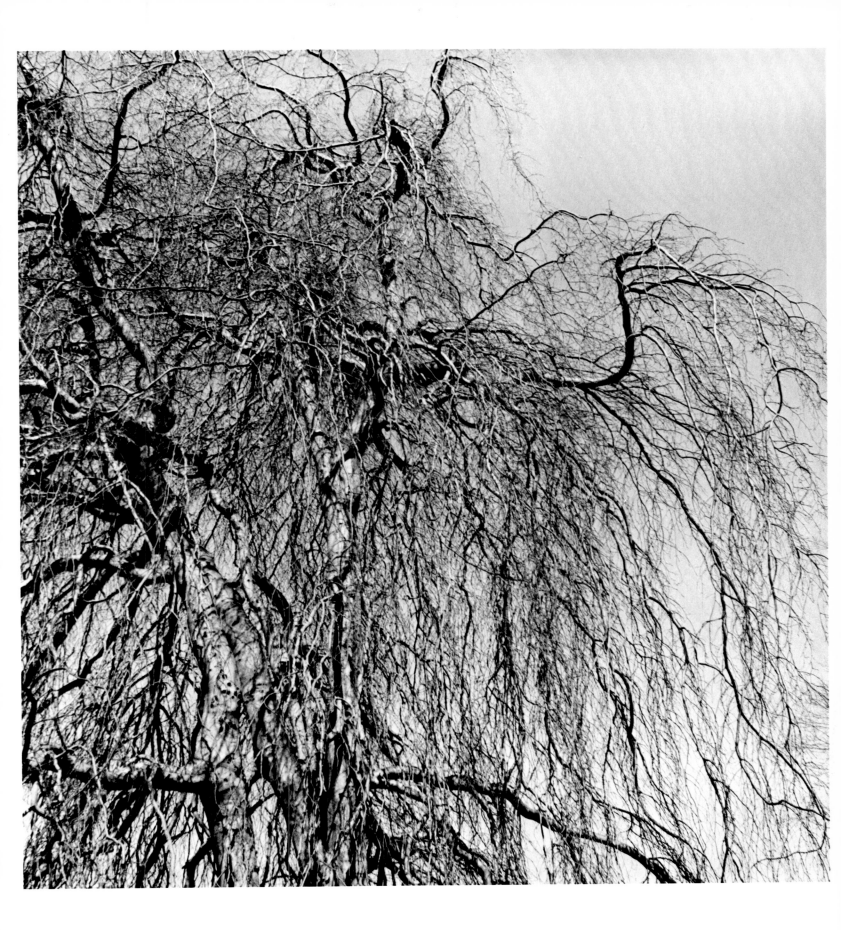

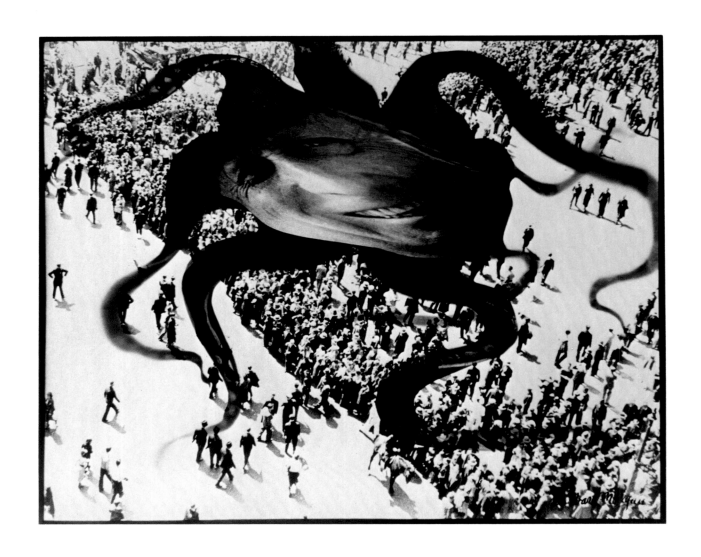

112 HEARST OVER THE PEOPLE, 1938-39. Photomontage
113 ARTIFICIAL LIFE FROM THE LABORATORY, 1967. Photomontage

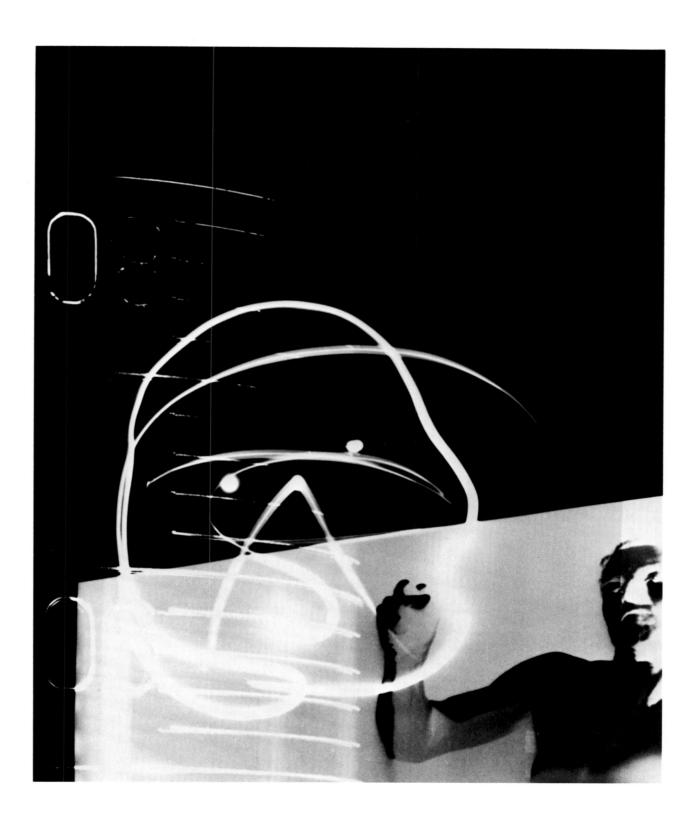

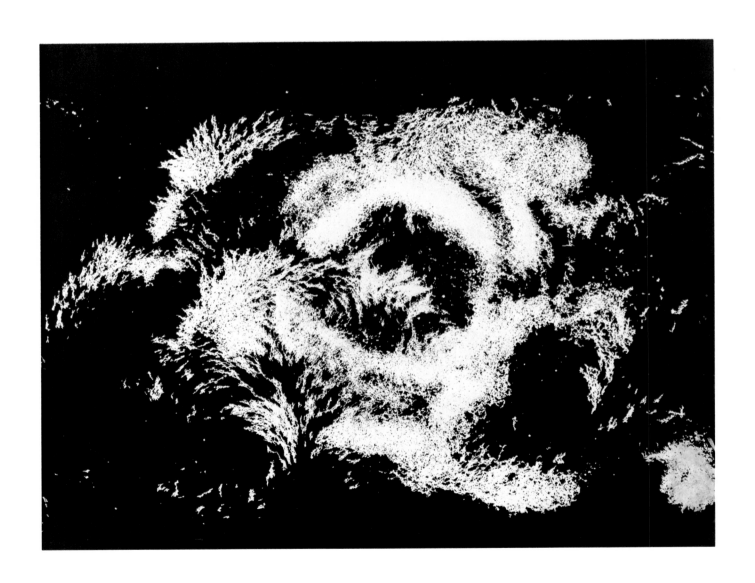

114 FORMING CURRENTS, 1970. Photogram
115 NANCY NEWHALL, 1942.

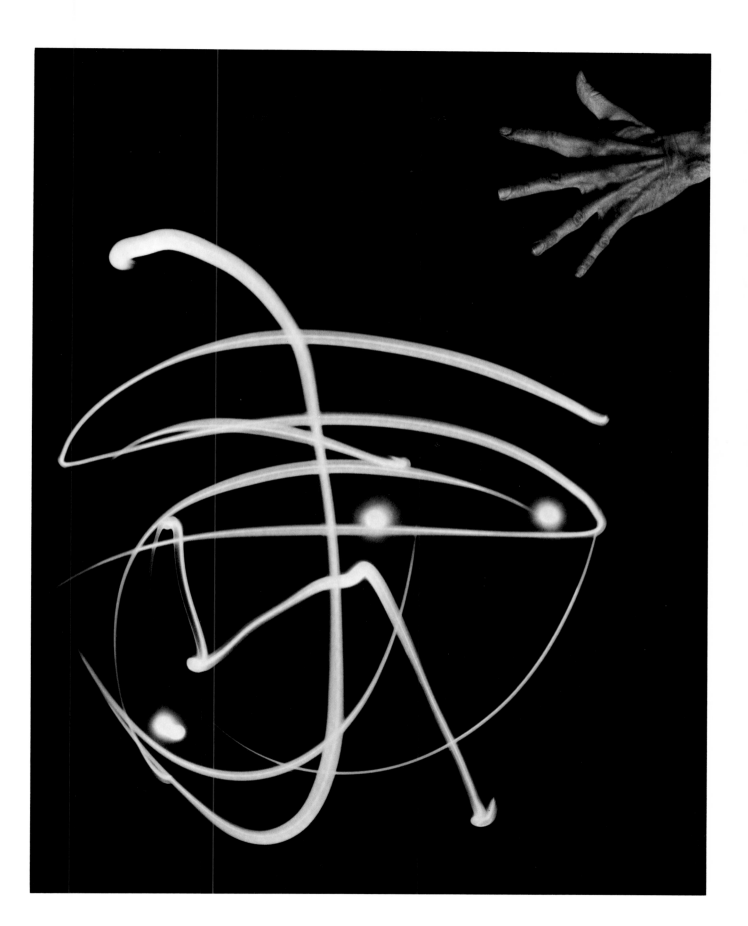

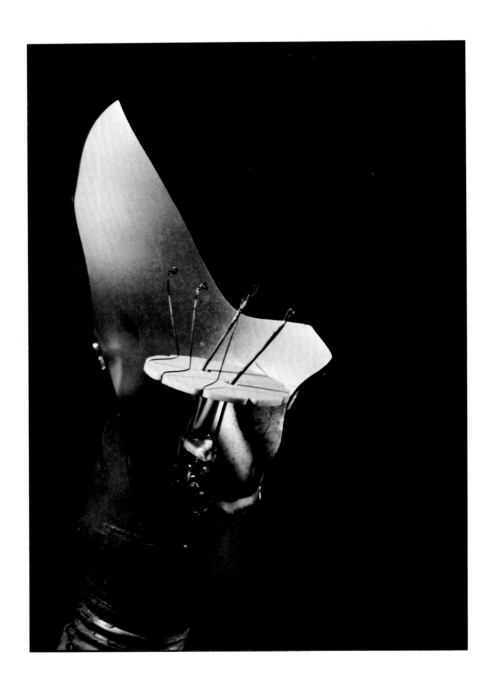

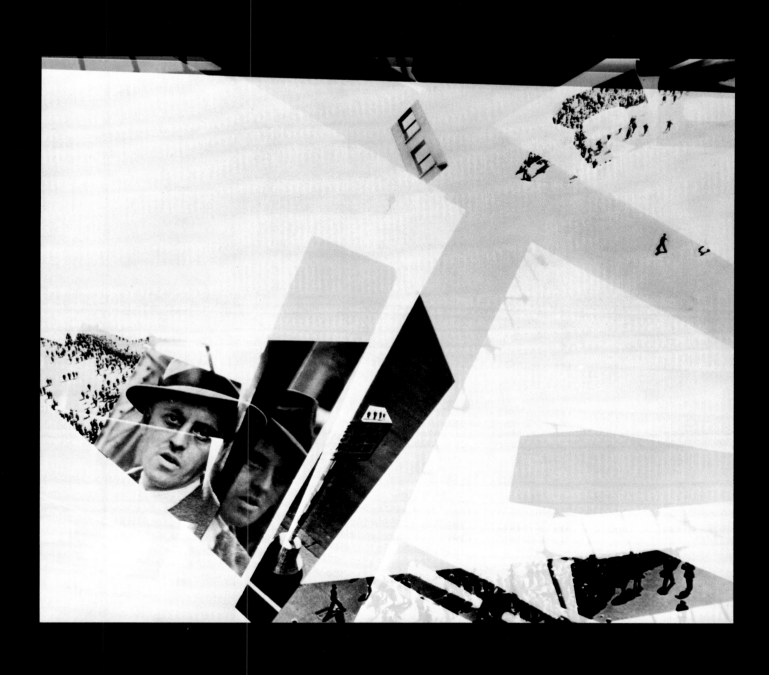

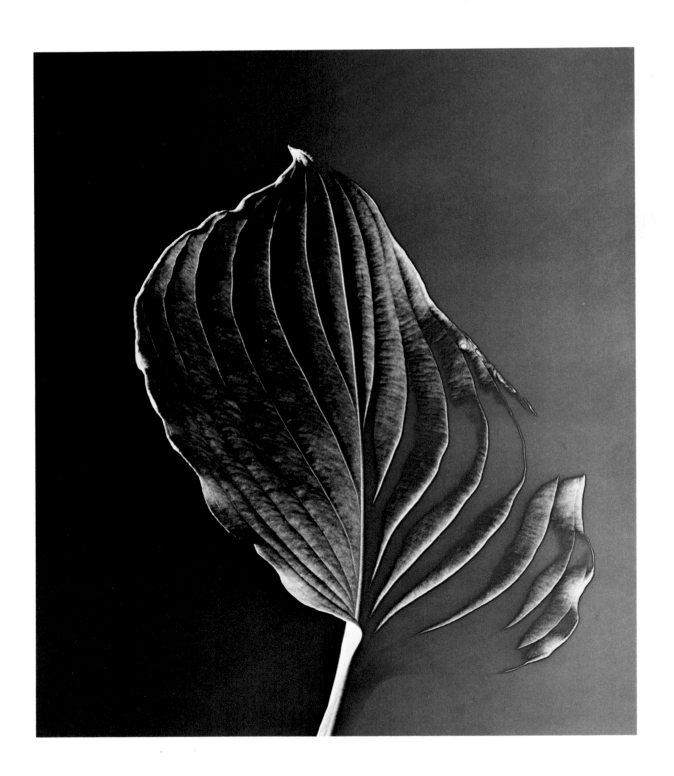

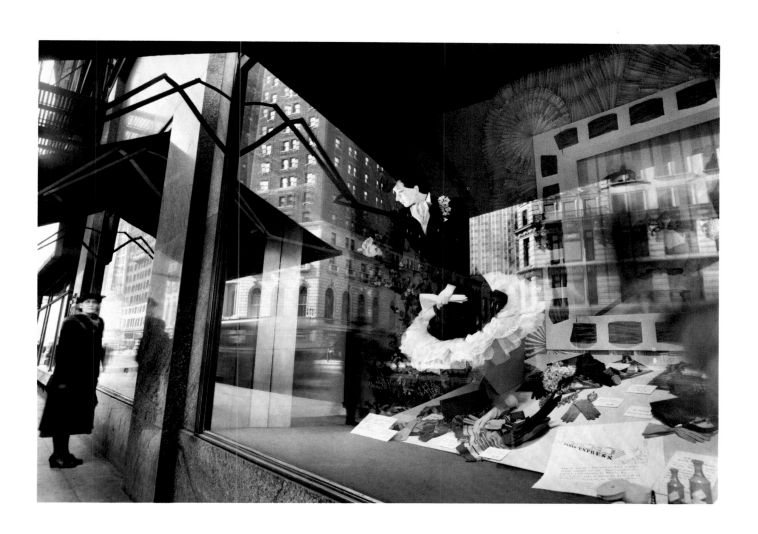

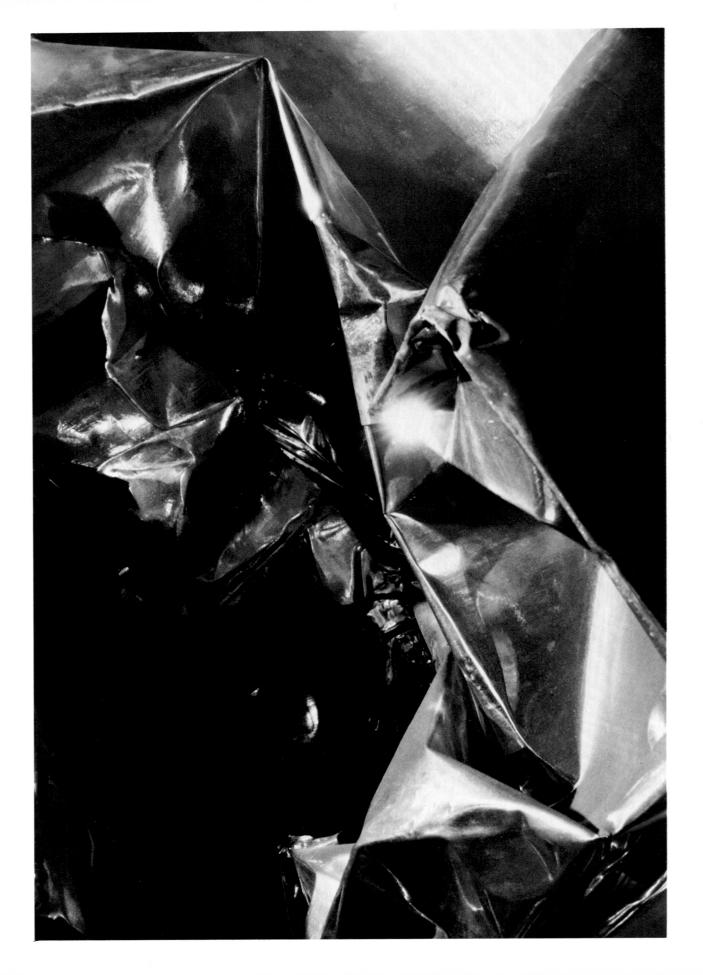

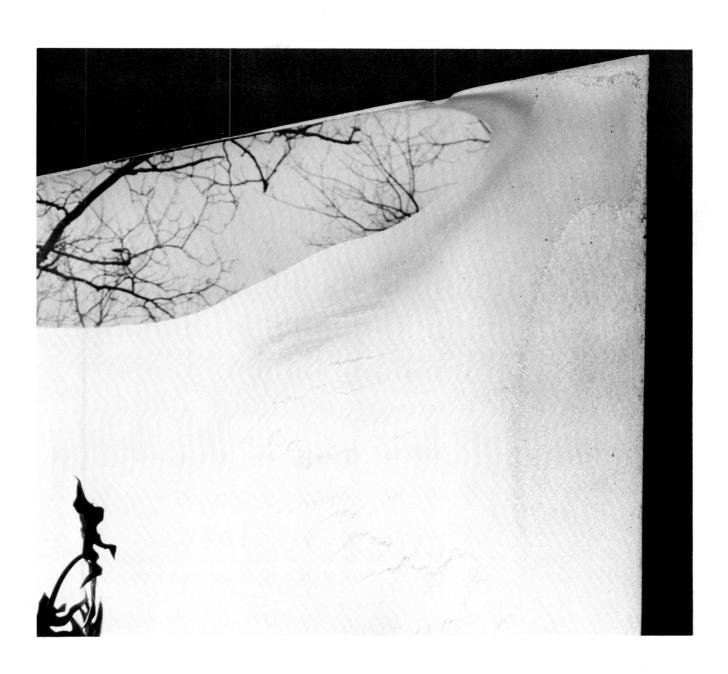

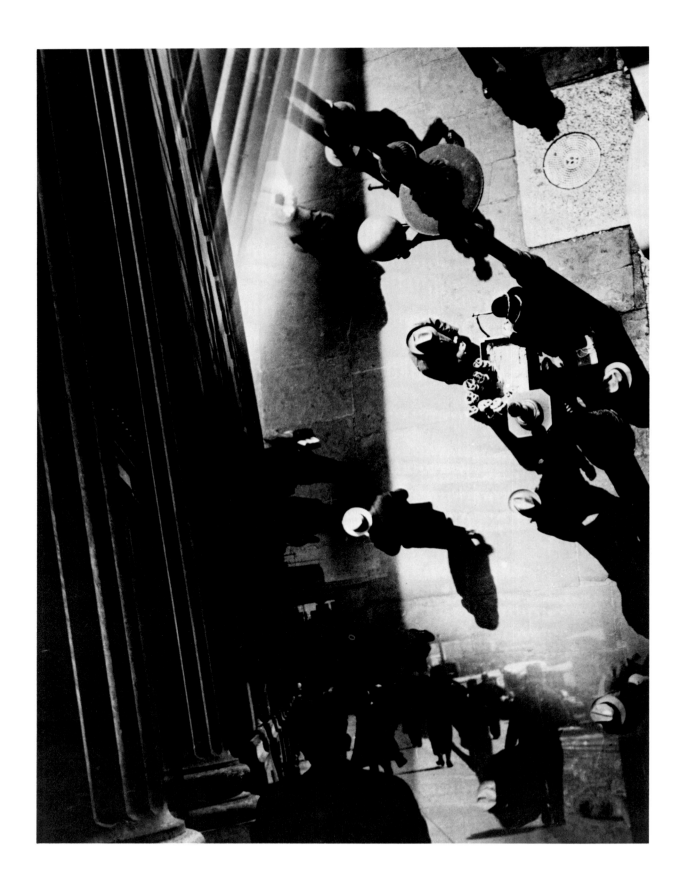

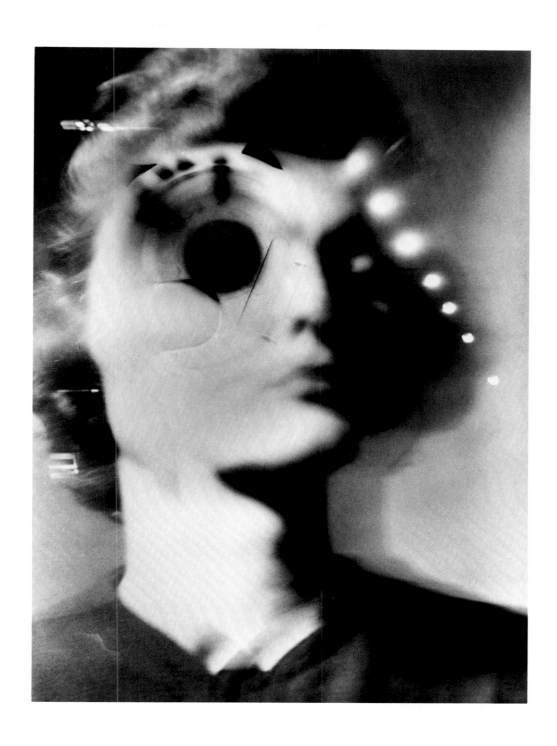

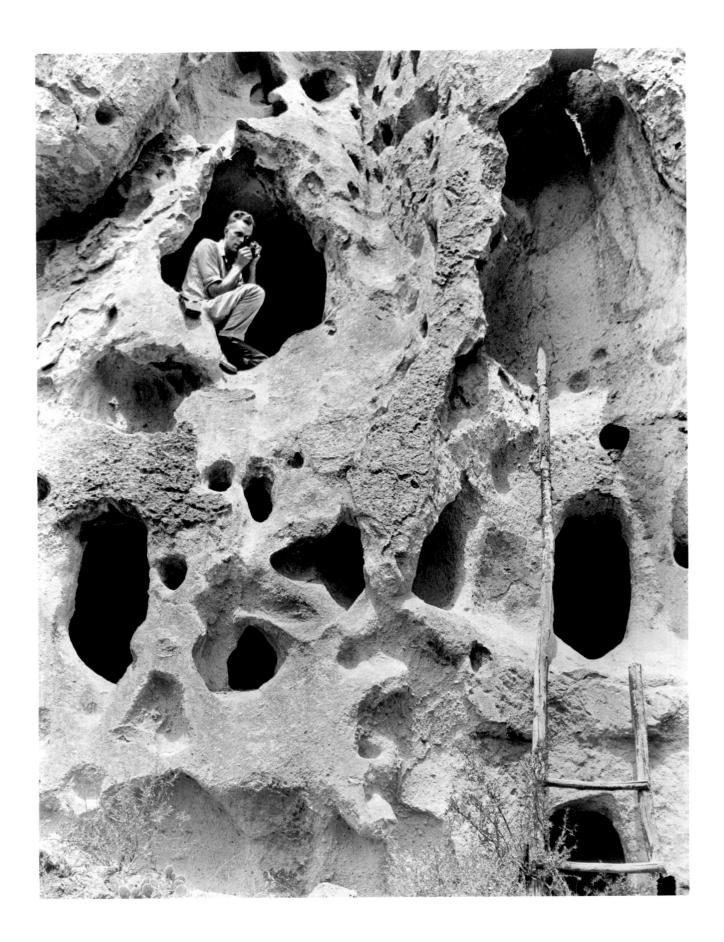

126 WILLARD MORGAN WITH MODEL A LEICA IN BANDELIER NATIONAL MONUMENT, NEW MEXICO, 1928.

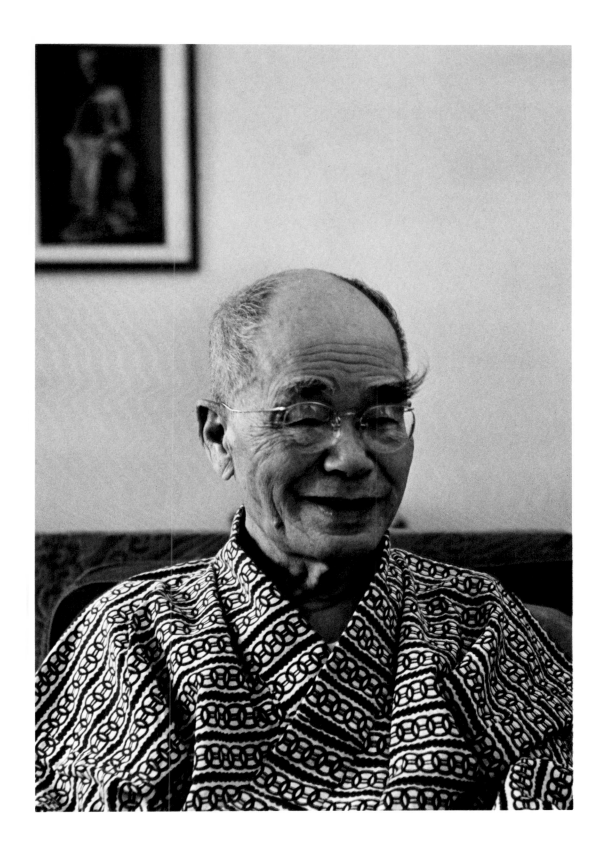

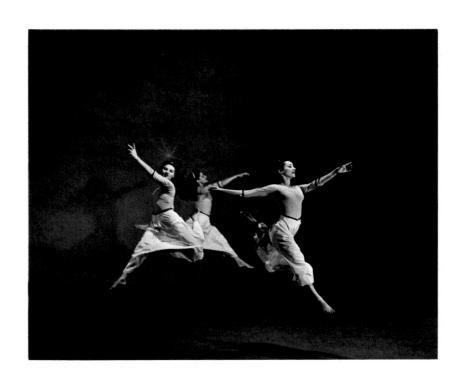

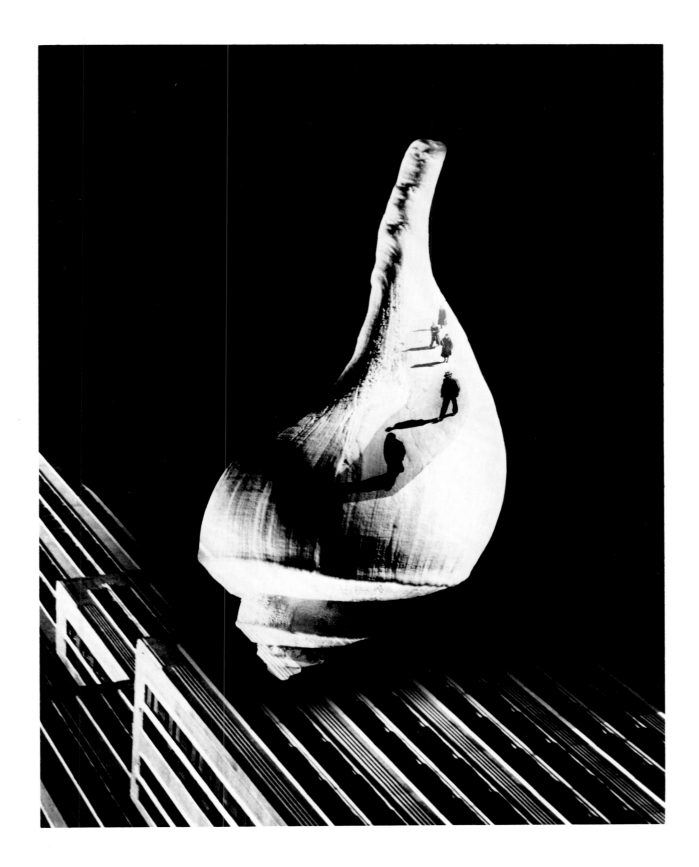

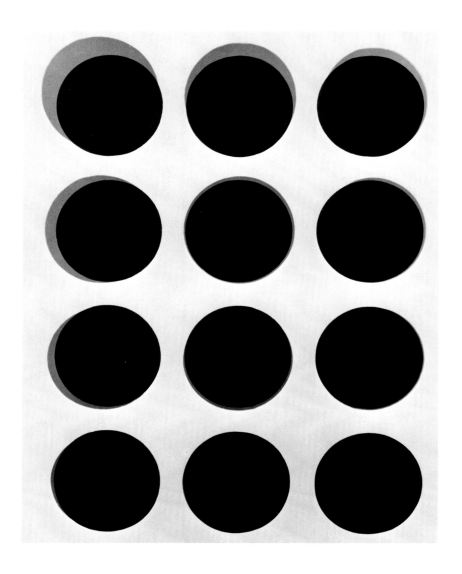

132 CHANGING GRID, 1970. Serial Photogram
133 BRIARLOCK, 1943. Photomontage

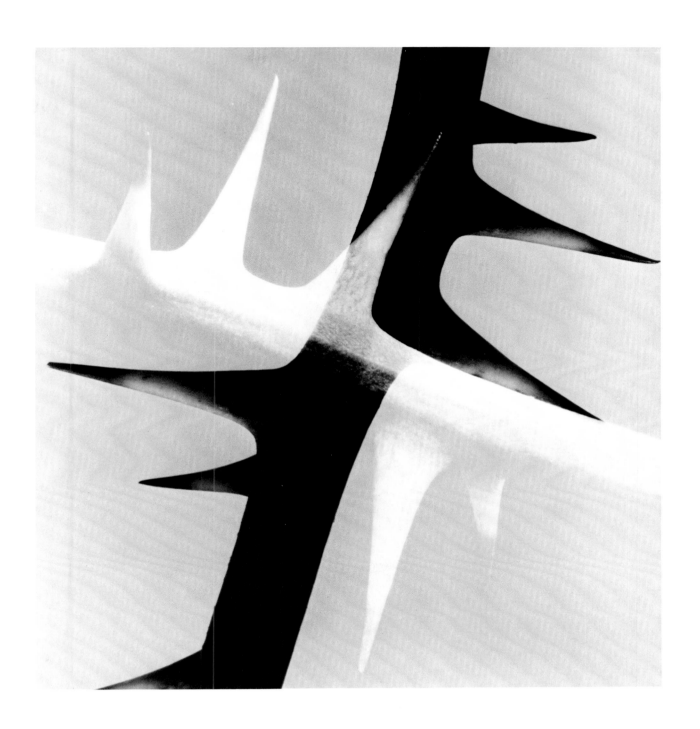

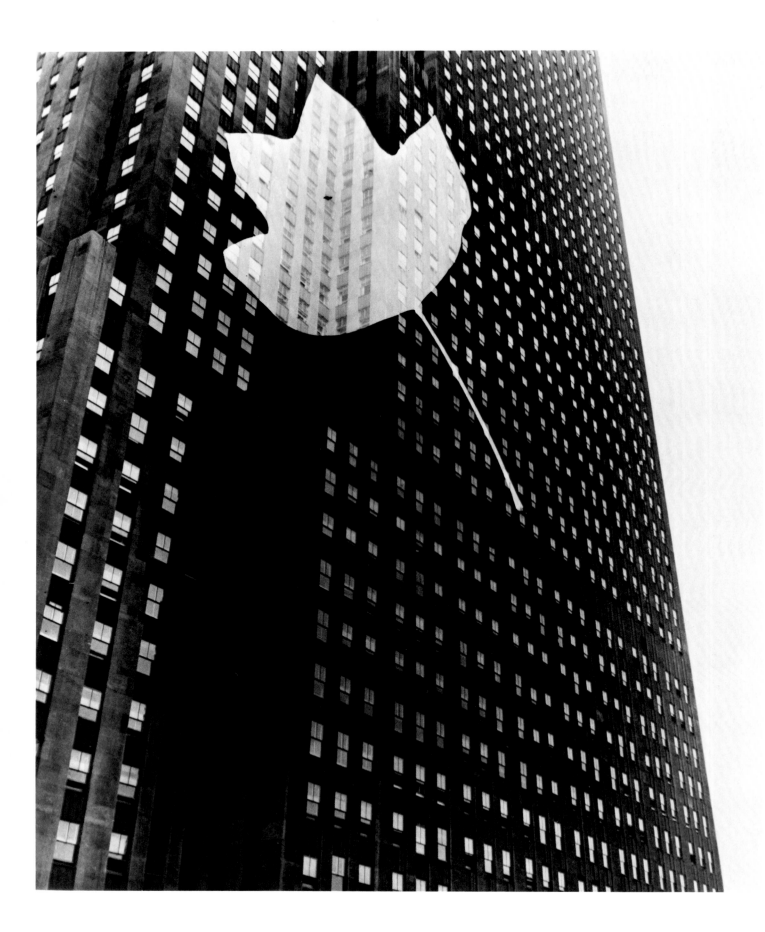

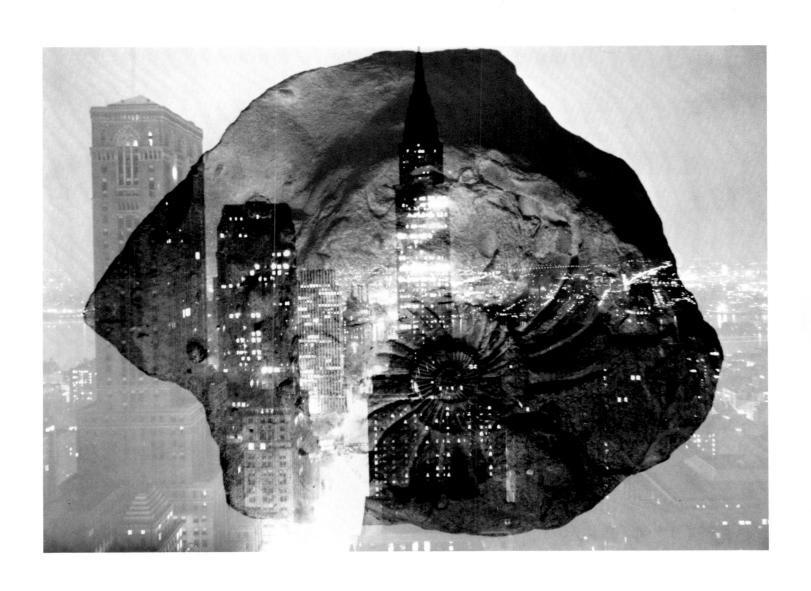

134 LEAF FLOATING IN CITY, 1970. Photogram-Photomontage
135 FOSSIL IN FORMATION, 1965. Photomontage

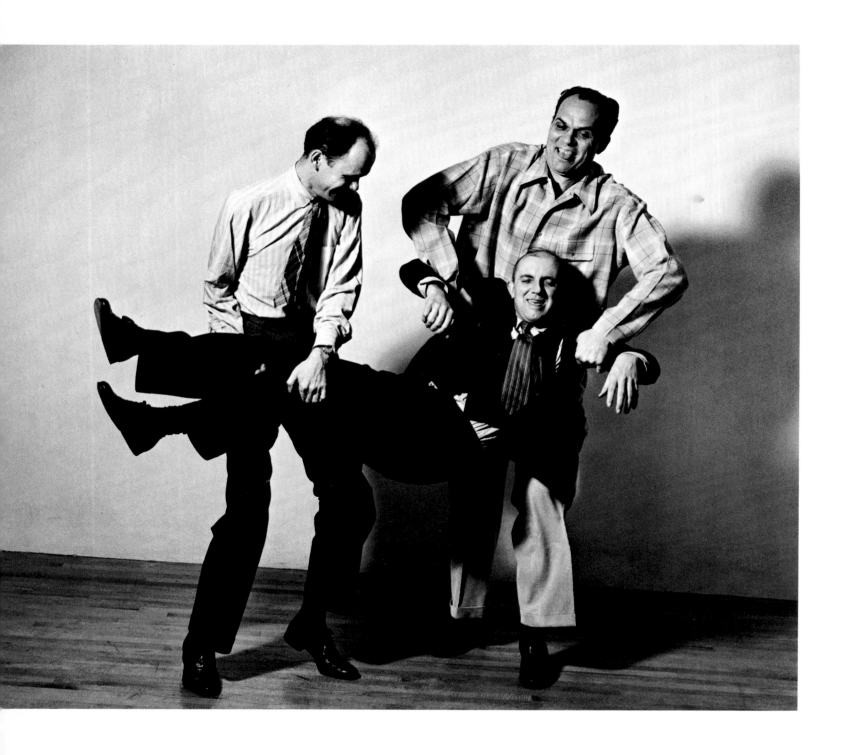

136 BEAUMONT NEWHALL, ANSEL ADAMS AND WILLARD MORGAN (in Barbara Morgan's studio), 1942.

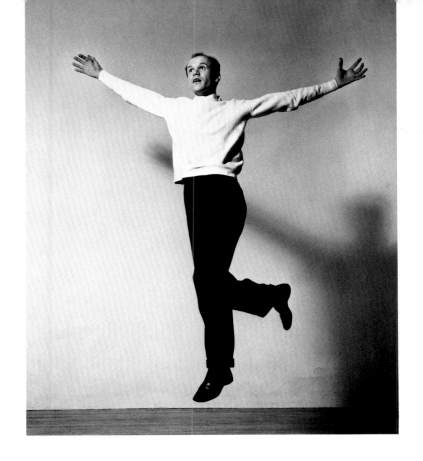

137 BEAUMONT NEWHALL LEAPING, 1942.

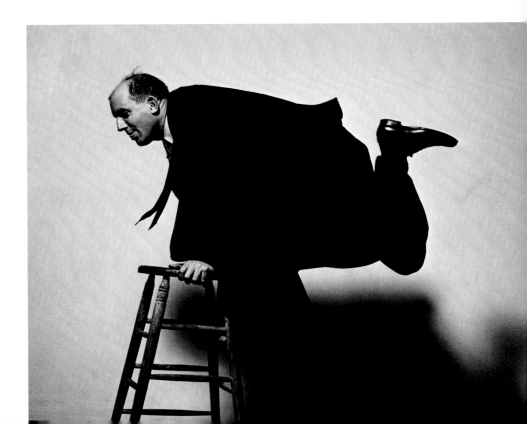

137 ANSEL ADAMS JUMPING ON STOOL, 1942.

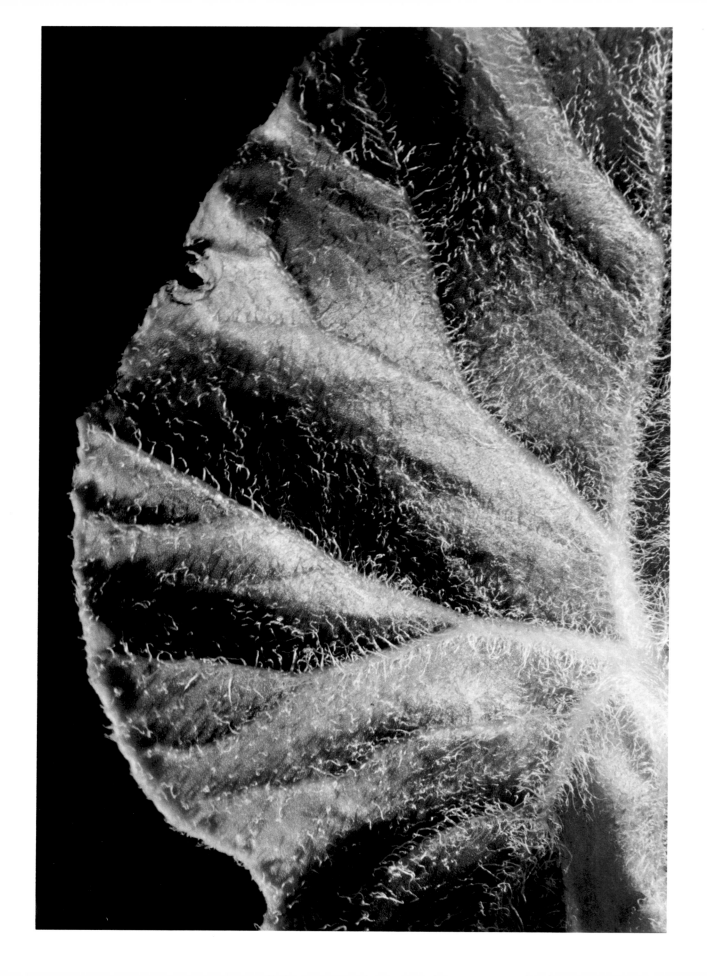

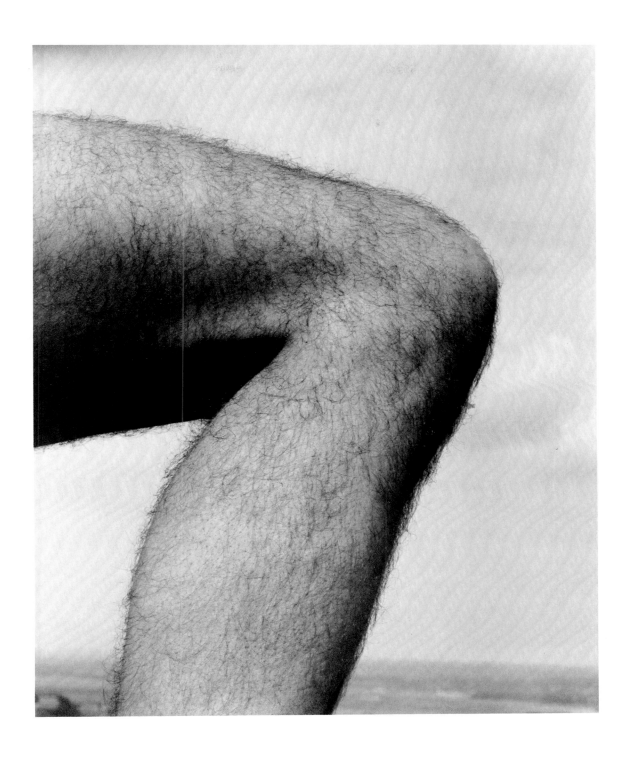

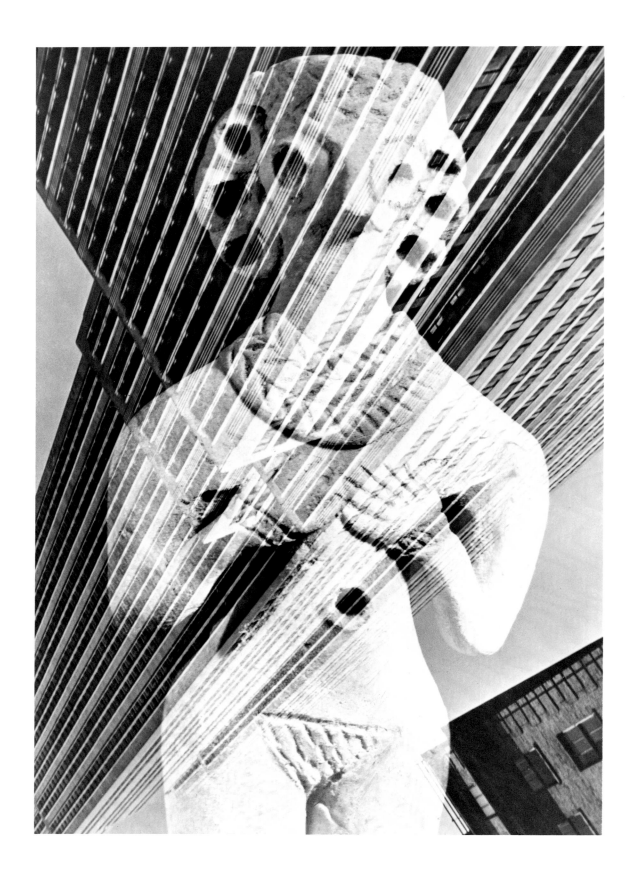

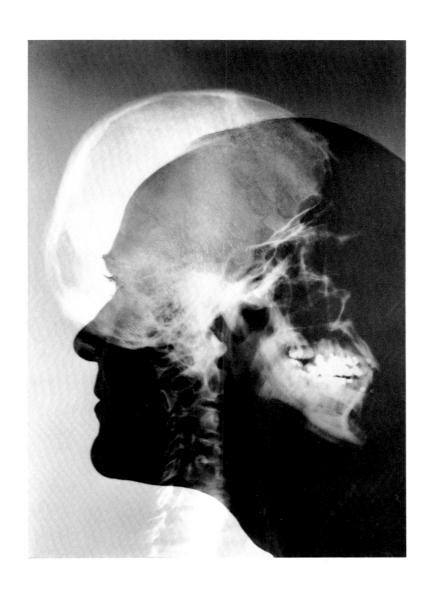

140 IKONS IN TIME-STREAM, 1963. Photomontage
141 INNER AND OUTER MAN, 1972. Photomontage

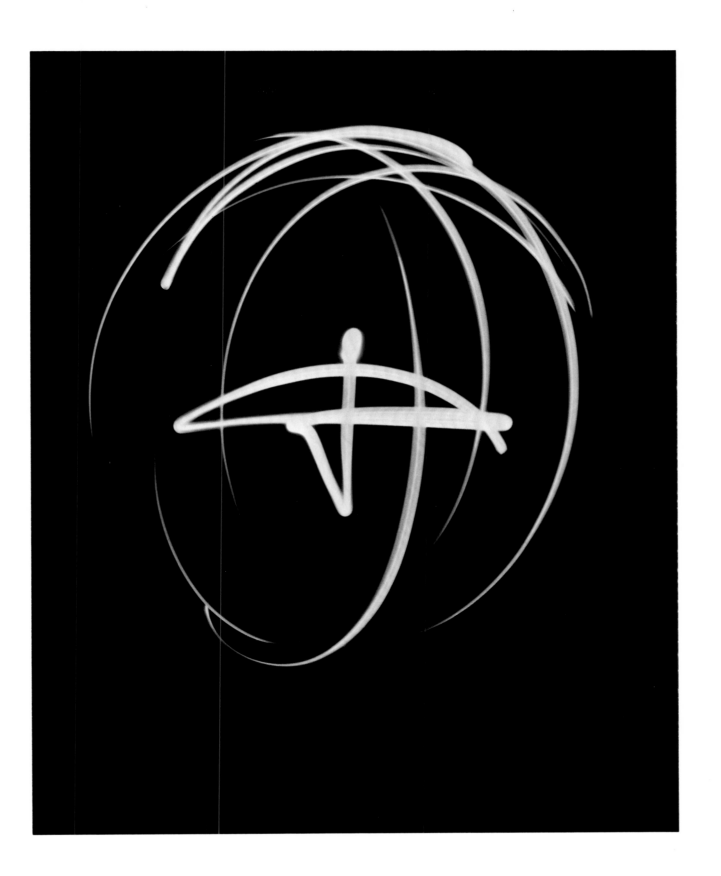

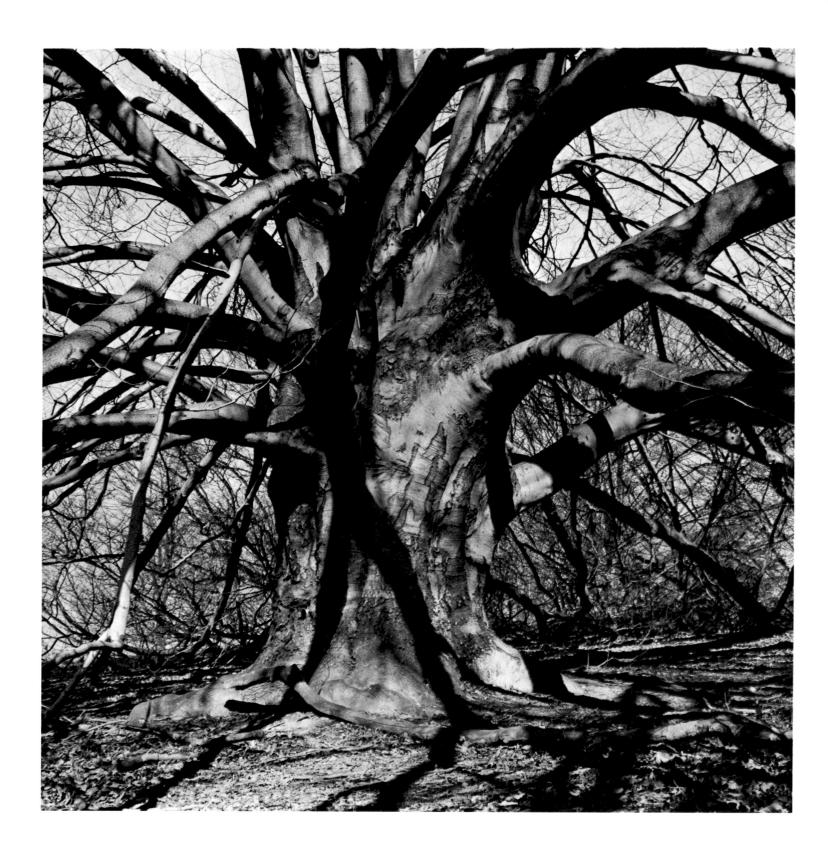

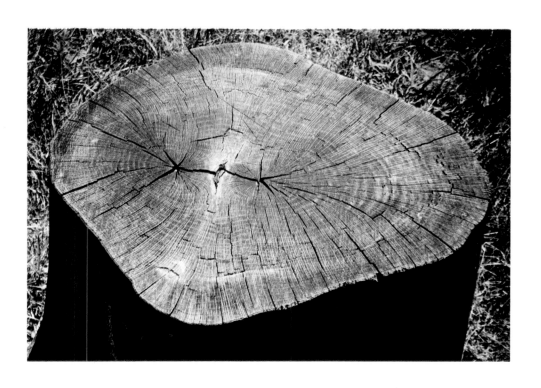

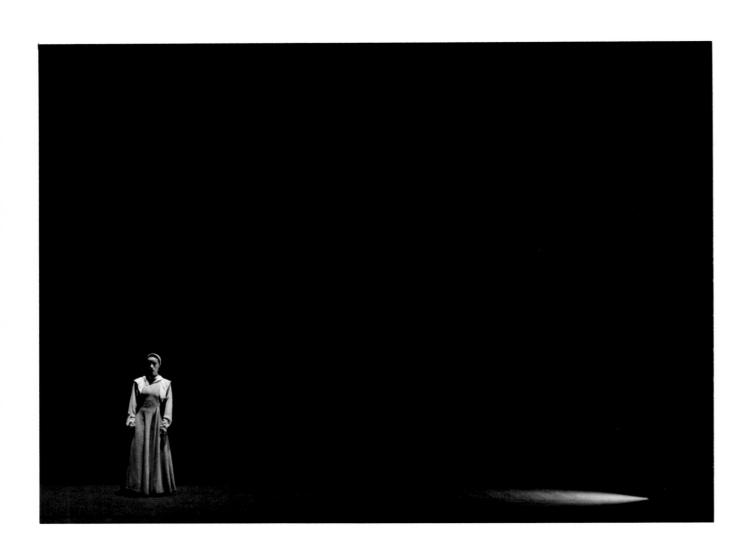

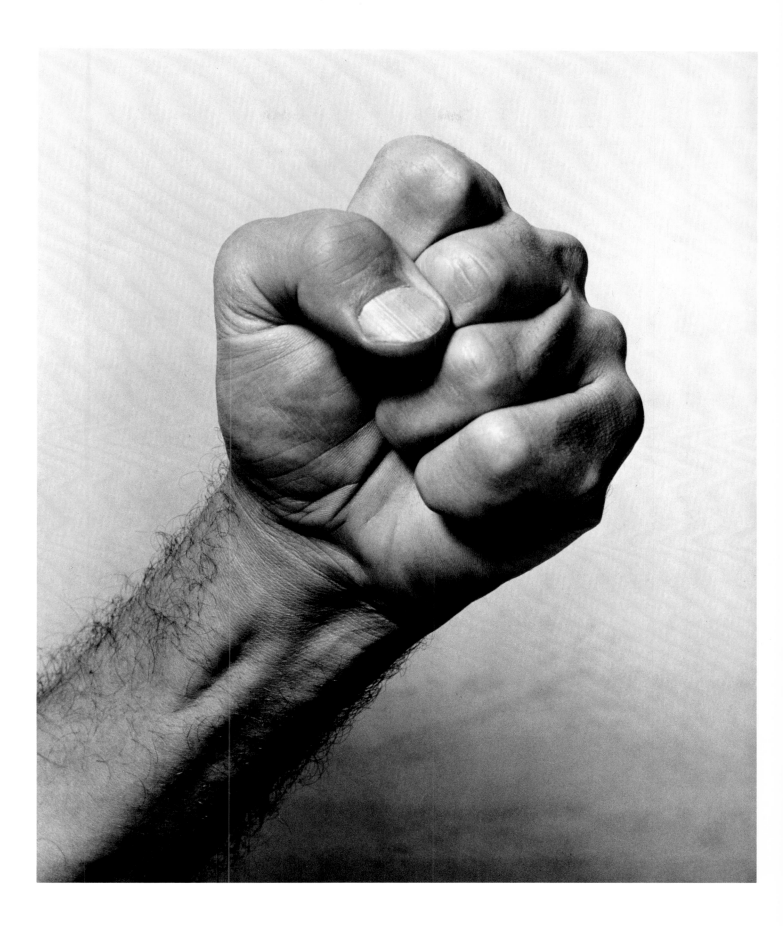

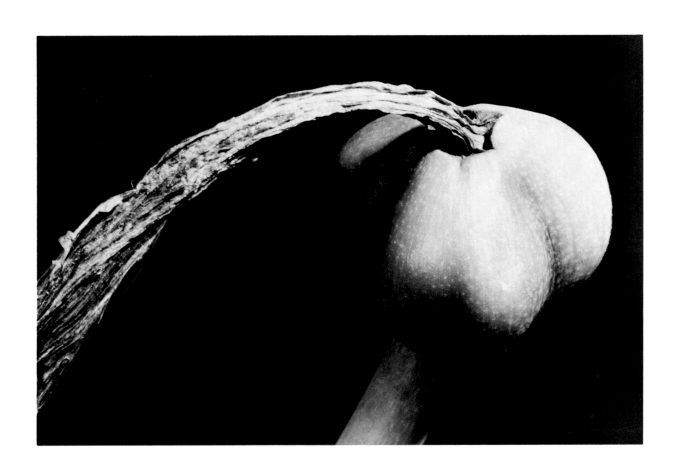

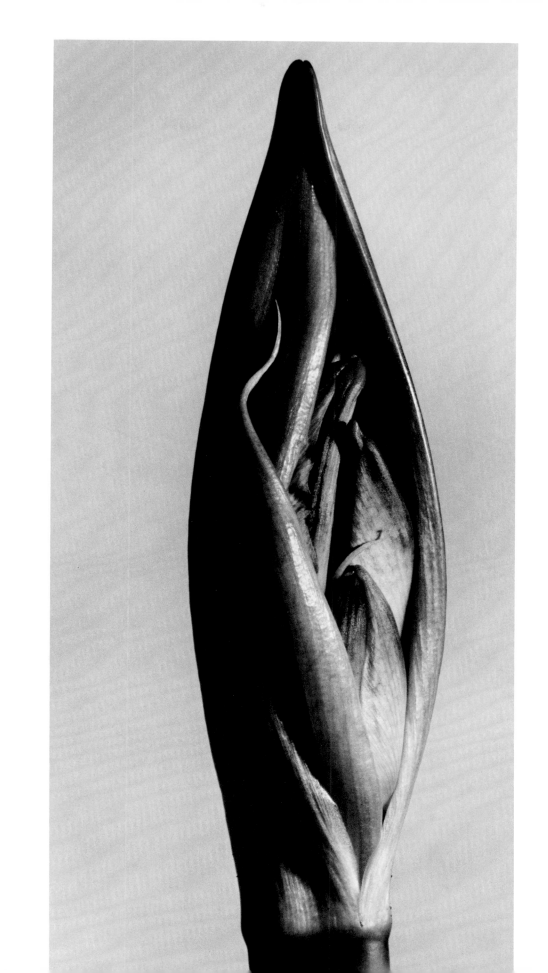

151 LLOYD'S HEAD, 1944.

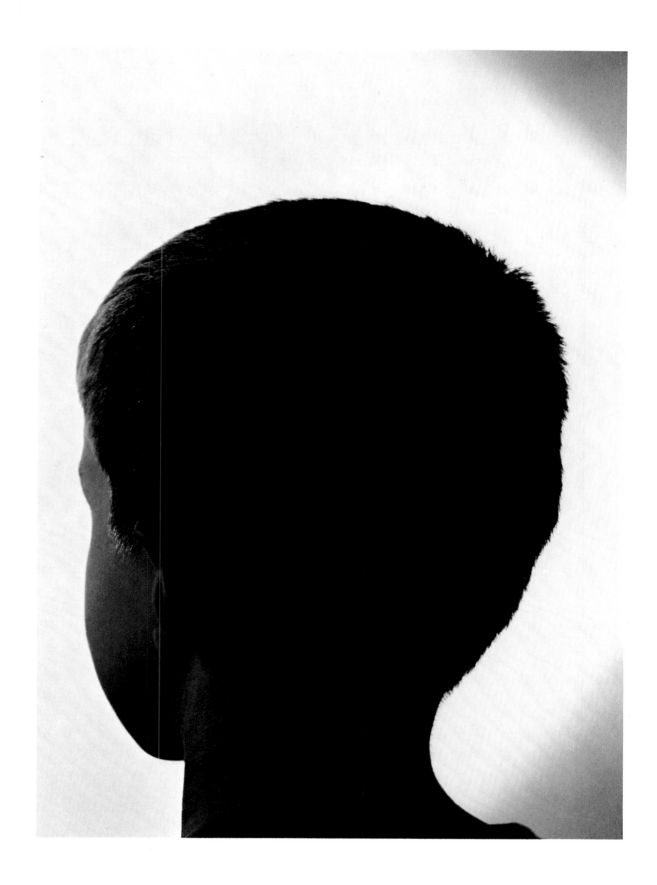

LIST OF PHOTOGRAPHS

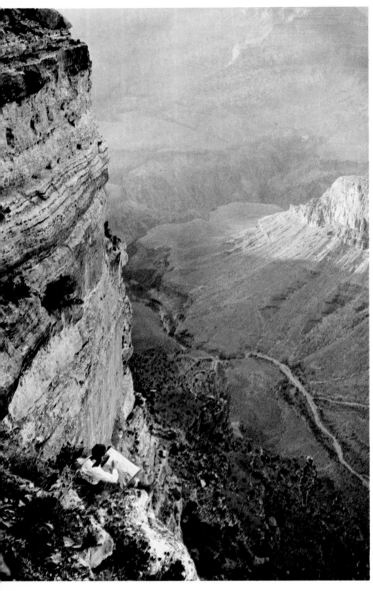

Photographed by Willard Morgan, 1928

WORKING THOUGHTS

The single most important art influence in my life came when I was about six years old. My father explained that "everything in the world is made of atoms and all the atoms are dancing." He would show me illustrations in the Scientific American, and best of all, whimsically encourage me to *"imagine everything dancing."* He would also say that the "things we can see with our eyes are a very small part of the world," and explain that gravity is invisible while holding the world together. "Can you imagine what would happen if it didn't?"

Some years later he explained metabolism—that everything changes, is born, grows and dies. In the overview nothing is static, all is in flux.

This childhood thought-patterning shaped the direction of my creative life: Imagination, motion, transformation, search for interior meaning—as it encompasses and relates to life.

Since childhood, I had always painted. In 1925 I was teaching in the U.C.L.A. Art Department, painting on weekends, exhibiting in local art societies.

When I married Willard in 1925 he was a young free-lance photographer, doing journalistic photography for his illustrations. He urged me to become a photographer, but I felt that "obvious record," involving no imagination could not be Art. But prophetically he would say, "You wait, photography will be the 20th Century Art."

But miraculously a day came when I helped a then unknown photographer, Edward Weston, hang his first exhibit at the U.C.L.A. Art Gallery. I saw for the first time photographs that were "realistic records"—yes, but also essentialized symbols. They were richly printed.

I was ecstatic. "Photography *can* be Art." Willard was right! But I had a flash feeling, "If I ever do photography, my subjects will have to move!"

Willard and I explored in the Southwest each summer while I taught at U.C.L.A. I painted for winter exhibits and Willard photographed to illustrate his articles on Ghost Towns, Indian Ceremonials, Cliff Ruins, etc. Though I photographed to help him, and was now appreciating photography, I never dreamed of being a photographer.

Those hours in Grand Canyon, in silent absorption, were awe inspiring. Our human species seemed negligible within those primordially eroded stratas of red sandstone, sculptured by grinding earth pressures, wind and water. Here and there dinosaur fragments and fossils were reminders that life "in process" was a prelude to Now. Shooting at 1/125 second at f/22, was Time within Timelessness.

In 1928 we both carried Leica Model A cameras and would try out challenges of flexibility in climbing Rainbow Bridge, Betatakin Cliff Dwelling, etc., where the view camera would have been precarious.

Attending Pueblo Indian Corn Dance, Rain Dance, Snake Dance and Navajo healing ceremonies were some of the most illuminating experiences of my life, which inspired me to photograph Modern American Dance. Later in New York, upon seeing Martha Graham's *Primitive Mysteries,* I knew she was attuned to the ambience of the Indian-Spanish Southwest.

To the American Indian and to Martha, dance is not mere theatrical virtuosity, but communal catharsis and the unification of Man and Nature; as it is in Greek Theatre and the Classic Dance of India. I realized her search for these values in our modern America.

In photographing action, I don't merely react to the surface form in motion, but basicly to the invisible axis of the form, in its space relation to other forms. The serene harmony of a tree comes from its vertical axis responding to gravity. The excitement of a leap comes from our empathy with another person whose axis is no longer "safe with gravity," but is in the oblique thrust-to-peak; then followed by the recovery axis changes from expended energy.

The interplay of these body-force centers are the real visual dynamics in a football game, rather than the surface forms and textures of sweaters, pants and skin; for it is axial counter-play that stirs the observer's kinetic response.

To prepare for actual shooting I watch breathing rhythms and other changes of mental states which catalyze physical exertion, for the body is an external vehicle of mood and will. But to portray the emotional-mental-spiritual expression is usually a more subtle problem that requires more empathy with the subject and more skill in pre-visioning the technical linkage.

My book, *Summer's Children,* grew from a wonderful association with the creative activities of Camp Treetops, where especially city children of varied backgrounds were in touch with Nature.

Caring for horses, goats, rabbits, sometimes racoons; making pottery; mountain climbing and canoeing; helping with the organic garden: such experiences developed warm satisfactions and group responsibility, which I photographed in unposed natural action, in a period when my own children were also growing.

It is the ecological invasion of Nature by the machine, the pollution, the urbanization imbalances of poverty, smog, crime, noise, that I try to express through the complex levels that photomontage can convey.

In SPRING ON MADISON SQUARE (page 28), I wanted to show that joyful exuberance can transcend dull, slogging winter. In FOSSIL IN FORMATION (page 135), there is the swirl of the millions of years old ammonite fossil enveloping the city. This concept came to me after an especially smoggy, noisy day in New York.

"CONTINUUM," (page 45) came from seeing autumn leaves in stages of being submerged in snow, ice and mud on their metabolic "return to the soil," and I composed the complex linear rhythms and textures to emphasize this natural recycling.

AMARYLLIS SEED POD and AMARYLLIS BUD (pages 148-149) are part of a series symbolic of Nature's growth cycles, so I used macro photography to monumentalize the normal scale into sculptural structures.

Photographic expression thrives on continuing experiment. Each time I print a negative, I try to let new waves of feeling for tone, space, and texture aid me in finding subtleties of interpretation that have matured through "Post-Vision." Therefore, since my work usually involves movement, I almost always shoot the original negative with a little all-around space for future experiment.

BARBARA MORGAN

BARBARA MORGAN CHRONOLOGIES Edited by WILLIAM SWAN

Chronology

1900 Born Barbara Brooks Johnson on July 8 in Buffalo, Kansas (11th generation American of English, Scotch, French and Welsh descent). Same year family moved to West Coast. Grew up on peach ranch in Southern California. From early childhood always painted.

1919 to 1923 Student, University of California at Los Angeles (UCLA), majoring in art. In Junior year began exhibiting paintings and woodcuts in West Coast art societies. Informal study of theater lighting and puppetry.

1923 and 1924 Taught art in San Fernando High School, San Fernando, California.

1925 Married Willard D. Morgan.

1925 to 1930 Joined art faculty, UCLA. Taught design, landscape and woodcut. Published *Block Print Book,* containing work of woodcut students. Served variously as writer, managing editor and editor, *Dark and Light* Magazine, Arthur Wesley Dow Association, UCLA. Painted and photographed in Southwest with Willard in summers. Met Edward Weston and realized photography as medium of artistic expression.

1930 Moved to New York City. Traveled for Willard Morgan's Leica Lectures. For study, photographed Barnes Foundation art collection, Merion, Pennsylvania.

1931 Established studio in New York for painting and lithography. Exhibited graphics at Weyhe Gallery, New York, and other galleries.

1932 Son Douglas born. Continued to exhibit paintings.

1934 One-man painting and graphics exhibition at Mellon Gallery, Philadelphia.

1935 Son Lloyd born. Motherhood responsibilities made painting impossible. Turned to photography since most work could be done at night.

1935 to 1941 Photographed, exhibited pictures of city themes, dance, children, photomontages and light drawings. Published book, *Martha Graham: Sixteen Dances in Photographs,* which was awarded American Institute of Graphic Arts Trade Book Clinic Award.

1935 to 1972 When needed, helped with photographic publishing projects: first for Morgan & Lester and later for Morgan & Morgan, Inc.

1941 Moved to Scarsdale, New York.

1941 to 1955 Continued photographic projects and exhibitions. Published second book, *Summer's Children: A Photographic Cycle of Life at Camp.* Did picture editing and design of book by Erica Anderson and Eugene Exman, *The World of Albert Schweitzer* (Harper & Row, N.Y., 1955).

1959 Art-archeological trip to Crete, Greece, Spain, Italy, France and England.

1961 One-man painting and graphics exhibition, Sherman Gallery, New York.

1967 Death of Willard Morgan.

1968 to 1972 Prepared major exhibitions and delivered numerous lectures and seminars.

Selected List of One-man Exhibitions

1938 "Dance Photographs," Y.M.H.A., Lexington Ave., New York, New York.

1939 "Dance Photographs," University of Minnesota, Minneapolis, Minnesota.
Duke University, Durham, North Carolina.
Kamin Dance Gallery, New York, New York.
"A Portfolio of the Dance," Columbia University, New York, New York.
Wheaton College, Norton, Massachusetts.

1940 Black Mountain College, Black Mountain, North Carolina.
"Dance Photograph Touring Exhibitions, I, II, III and IV,"

circulated to over 150 colleges, museums and galleries. Continued until 1943.

Dock Street Theater, Charleston, South Carolina.

Greenwich Library, Greenwich, Connecticut.

"Photographs of the Dance," Photo League, New York, New York.

Pratt Institute, Brooklyn, New York.

University of Minnesota, Minneapolis, Minnesota.

1941 Wesleyan University, Middletown, Connecticut.
Baltimore Museum of Art, Baltimore, Maryland.

1943 "Modern Dance in Photography," Carleton College, Northfield, Minnesota.
Y.M.H.A., Lexington Ave., New York, New York.

1944 Black Mountain College, Black Mountain, North Carolina.
"The Dance," First Annual Arts Forum, The Woman's College of the University of North Carolina, Greensboro, North Carolina.

1945 Jewish Community Center, Detroit, Michigan.
"Modern American Dance," Museum of Modern Art, New York, New York. Spanish and Portuguese versions prepared for the Inter-American Office of the National Gallery of Art for circulation in Latin America. Portuguese version shown at United Nations Conference, San Francisco, during first formative session.

1946 University of Redlands, Redlands, California.
University of Minnesota, Minneapolis, Minnesota.
University of Wisconsin, Madison, Wisconsin.

1947 World Youth Festival, Prague, Czechoslovakia.

1952 "Summer's Children," Bankers Federal Savings and Loan, New York, New York.
"Summer's Children," New York Public Library, New York, New York.

1955 "Summer's Children," George Eastman House, Rochester, New York.

1956 "Summer's Children," Kodak Photographic Information Center, Grand Central Terminal, New York, New York.

1957 *Parents' Magazine* Gallery, New York, New York.

1959 Twelfth American Dance Festival, Connecticut College, New London, Connecticut.

1962 Arizona State University, Tempe, Arizona.

1964 George Eastman House, Rochester, New York.
Société Francaise de Photographie, Paris, France.

1965 Briarcliff Public Library, Briarcliff Manor, New York.
Carnegie Institute of Technology, Pittsburgh, Pennsylvania.
Ceeje Galleries, Los Angeles, California, (paintings and photographs).
University of Louisville, Louisville, Kentucky.

1969 Long Island University, Brooklyn Center, Brooklyn, New York.

1970 "Barbara Morgan: Women, Cameras, and Images IV," Smithsonian Institution, Washington, D. C.
Friends of Photography Gallery, Carmel, California.

1971 831 Gallery, Birmingham, Michigan.
Montclair Art Museum, Montclair, New Jersey.
Phoenix Evening College, Phoenix, Arizona.
Utah State University, Logan, Utah.

1972 Amon Carter Museum of Western Art, Fort Worth, Texas.
Focus Gallery, San Francisco, California
Museum of Modern Art, New York, New York.
Ohio Silver Gallery, Los Angeles, California.

Books by Barbara Morgan

Martha Graham: Sixteen Dances in Photographs, Duell, Sloan and Pearce, New York, 1941.

Prestini's Art in Wood, (text by Edgar Kaufmann, Jr.), Pocahontas Press, Lake Forest, Illinois, 1950.

Summer's Children, Morgan & Morgan, Scarsdale, N. Y., 1951.

Selected List of Articles by Barbara Morgan

1938 "Photomontage," *Miniature Camera Work,* Morgan & Lester, New York, 1938, pp. 145-166, ill.

1940 "Photographing the Dance," *Graphic Graflex Photography,* Morgan & Lester, New York, 1st ed., 1940, pp. 230-239, ill.

1941 "Dance Into Photography," *U. S. Camera,* Dec. 1941, pp. 102 and following.

1942 "Dance Photography," *The Complete Photographer,* National Educational Alliance, New York, 18:3, March 10, 1942, pp. 1133-1146, ill.
"In Focus: Photography, The Youngest Visual Art," *Magazine of Art,* 35:7, Nov. 1942, pp. 248-255, ill.

1944 "The Scope of Action Photography," *The Complete Photographer,* National Educational Alliance, New York, 10:4, Mar. 20, 1944, pp. 289-309, ill.

1944 "Growing Americans: Shooting Stills for a Government Short," *U. S. Camera,* VII:1, Feb. 1944, pp. 44-47, 54, ill.

1945 "Modern Dance," *Popular Photography,* 16:6, June 1945, pp. 44-47, 68, ill.

1952 "Is Black & White Better Than Color? No! Says Ivan Dmitri, Yes! Says Barbara Morgan," *Modern Photography,* July 1952, pp. 52-57, 86, ill.

1953 "Kinetic Design In Photography," *Aperture,* No. 4, 1953, pp. 18-27, ill.

1955 "The Theme Show: A Contemporary Exhibition Technique," *Aperture,* 3:2, 1955, pp. 24-27.
"The World of Albert Schweitzer," *Publishers' Weekly,* 167:1, Jan. 1, 1955, pp. 68-74, ill.

1956 "Photographer's Ego vs. An Anonymous (?) Medium," *Spectrum Magazine,* (Rhode Island School of Design, Providence, R. I.), VI:2, 1956, pp. 12, 21-22.

1963 "Abstraction in Photography," *Encyclopedia of Photography,* Greystone, New York, 1963, Vol. 1, pp. 57-61, ill.
"Advancing Photography as a Fine Art," *Encyclopedia of Photography,* Greystone, New York, 1963, Vol. 1, pp. 77-87, ill.
"Aspects of Photographic Interpretation," *General Semantics Bulletin,* No. 3-31, 1963/64, pp. 44-49, ill.
"Dance Photography," *Encyclopedia of Photography,* Greystone, New York, 1963, Vol. 6, pp. 1013-1024, ill.
"Esthetics of Photography," *Encyclopedia of Photography,* Greystone, New York, 1963, Vol. 7, pp. 1294-1308, ill.
"Juxtapositions in Photography," *Encyclopedia of Photography,* Greystone, New York, 1963, Vol. 10, pp. 1896-1904, ill.

1964 "Barbara Morgan," *Aperture,* (monograph), 11:1, 1964, ill.
"Photomontage," *Encyclopedia of Photography,* Greystone, New York, 1964, Vol. 15, pp. 2841-2851, ill.
"Scope of Action Photography," *Encyclopedia of Photography,* Greystone, New York, 1964, Vol. 18, pp. 3330-3345, ill.

1965 "Russell Lee, Photographer," in *Russell Lee—Retrospective Exhibition 1934-64,* (catalogue), University Art Museum, University of Texas, Austin, 1965, p. 4.

1971 "My Creative Experience with Photomontage," *Image,* 14:5-6, 1971, pp. 18-20, ill.

Selected List of Articles about Barbara Morgan

1938 Kelley, Etna M., "Barbara Morgan: Painter Turned Photographer," *Photography,* 6:73, Sept. 1938, pp. 6-7, ill.

1941 Isaacs, Edith J. R., "Graham Dance Record," *Theatre Arts Monthly,* Dec. 1941.
Lloyd, Margaret, "Portraits of Energy," *Christian Science Monitor,* Nov. 1, 1941, p. 11, ill.
"Martha Graham: Sixteen Dances in Photographs-by Barbara Morgan," (book review), *U. S. Camera,* Dec. 1941, pp. 84-86, ill.
McCausland, Elizabeth, "Dance Photographs by Barbara Morgan," *Springfield Sunday Union and Republican,* Sept. 7, 1941, p. 6E, ill.

1944 "A Danca Moderna," *Em Guarda,* (Brazil), 4:7, 1944, pp. 40-41, ill.

1945 "Apertura de la Exposicion 'La Danza Moderna Norteamericana'," *El Mundo,* (Havana), Sept. 21, 1945, ill.
"National Gallery Sends Shows to Latin America," *Museum News,* 23:2, May 15, 1945, p. 1.
"A Photographic Exhibition of the Modern American Dance," *Dance Observer,* May 1945, pp. 53-54.

1947 "Photographic Exhibition of Modern Dance," *The Standard,* (Argentina), June 19, 1947, ill.
"Photographic Study of the 'Modern Dance'," *Buenos Aires Herald,* June 24, 1947, p. 7.

1949 Newhall, Beaumont, *The History of Photography from 1839 to the Present Day,* Museum of Modern Art, New York, 1949, p. 163, 198-200, ill.

1951 Abbott, Berenice, *"Summer's Children,"* (book review), *American Photography,* Nov. 1951, pp. 678-679, ill.
Benet, Rosemary, *"Summer's Children* by Barbara Morgan," (book review), *Book-of-the-Month Club News,* Oct. 1951, p. 19.
Newhall, Nancy, "Journey Into Childhood," *Popular Photography,* Oct. 1951, pp. 146-147, ill.
"Summer's Children by Barbara Morgan," (book review), *Art News,* Sept. 1951, p. 9.

1952 Haskell, Helen, "Summer's Children: Life at Camp," *Living Wilderness,* 17:41, Summer 1952, pp. 8-12, ill.
Lewis, Harold, "On Illustrating a Book," *Photography,* 7:4, April 1952, pp. 29-32, ill.
Neugass, Fritz, "Great American Photographers: Barbara Morgan," *Camera,* 31:2, Feb. 1952, pp. 50-51, ill.
Newhall, Beaumont, "Barbara Morgan, *Summer's Children,"* (book review), *Magazine of Art,* Mar. 1952, p. 141.
"Summer's Children," (book review), *Childhood,* June 1952, pp. 37-39, ill.

1954 Hering, Doris, ed., *25 Years of American Dance,* Orthwine, New York, 1954, p. 121.

1964 "Barbara Morgan," *Encyclopedia of Photography,* Greystone, New York, 1964, Vol. 13, pp. 2373-2375, ill.

1965 Bennett, Edna, "The Boom In Picture Books," *U. S. Camera,* 28:3, Mar. 1965, pp. 68-71, ill.
Neugass, Fritz, "Die vielen Gesichter der Barbara Morgan," *Foto Magazin,* (Munich), July 1965, pp. 38-41, ill.

1969 Deschin, Jacob, "Archival Printing—Push for Permanence," *Popular Photography,* 69:2, Aug. 1969, p. 30, ill.

1971 Deschin, Jacob, "Barbara Morgan: Permanence Through Perseverance," *Photography Annual,* 1971, pp. 6-24, 166-167, ill.
Hering, Doris, "Barbara Morgan: One of America's Great Photographers Reflects a Decade of Dance 1935-1945," *Dance Magazine,* July 1971, pp. 43-56, ill.

1972 Coppens, Jan, "Barbara Morgan: fotografe tussen twee wereldoorlogen," *Foto,* (Amsterdam), 27:7, July 1972, pp. 28-29, ill.

Selected List of Lectures and Seminars by Barbara Morgan

1939 "Dance Photography and Photo-Montage," Brooklyn Museum, Brooklyn, N.Y.
"Photomontage," Photo League, New York, N.Y.

1940 "Contemporary Photography," Brooklyn Community Art Center, New York, N.Y.
"Photography of the Dance," Manhattan Camera Club, New York, N.Y.

1941 Clarence H. White School of Photography, New York, N.Y.

1942 "Photography vs. Painting," WABC Radio (with Reginald Marsh), New York, N.Y.

1943 "Photography and the Modern Dance," Y.M.H.A. Lexington Ave., New York, N.Y.
"Action Photography," Museum of Modern Art, New York, N.Y.

1944 "Imagination In Photography," Museum of Modern Art, "Photographic Vision" and "Control of Elements and Technique in Photographic Expression," Black Mountain College, Black Mountain, North Carolina.

1945 "Creative Lighting," Museum of Modern Art, New York, N.Y.

1947 "Photography As A Creative Art," ASMP Symposium, New School for Social Research, New York, N.Y.

1956 Village Camera Club, New York, N.Y.

1960 "From Cave Paintings to Contemporary Art," ten lectures, Edgemont Adult School, Scarsdale, New York.

1963 "Aspects of Photographic Interpretation," Conference on General Semantics, Institute of General Semantics, New York University, New York, N.Y.
"Modern Aesthetics in Music and Art," panel discussion, Westchester Art Society Gallery, White Plains, New York.

1964 "The Future of Pictures in the Library," panel discussion, Special Libraries Association, Donnell Library, New York, N.Y.

1965 "Dynamics of Composition," Hudson River Museum, Yonkers, New York.

1968 "Analogue: A Conversation Between Barbara Morgan and Gordon Parks on Their Experiences in Photography," Radio WLIB, New York, N.Y.

1970 Summer Dance Festival, Connecticut College, New London, Connecticut.
Visual Studies Workshop, Rochester, New York.

1971 Ansel Adams Yosemite Workshop, Yosemite, California.
Bennington College, Bennington, Vermont.

"Objective/Subjective Vision," Montclair Art Museum, Montclair, New Jersey.

Oral History Program Interview Sessions, University of California at Los Angeles.

1972 Ansel Adams Yosemite Workshop, Yosemite, California. Cooper Union Forum, New York, N.Y.

Selected List of Group Exhibitions

1937 "First Annual Membership Exhibition," American Artists' Congress, New York, N.Y.

1938 "International Photographic Exposition," Grand Central Palace, New York, N.Y.
"Outstanding Women Photographers of America," Carl Zeiss, Inc., New York, N.Y., circulated nationally by Junior League.

1939 "Art in a Skyscraper," American Artists' Congress, New York, N.Y.
"Dance Exhibition," Los Angeles Museum of History, Science and Art, Los Angeles, California.

1940 "American Dancing," Museum of Modern Art, New York, N.Y.
"Invitational Salon," Photographic Society of America, Worlds Fair, New York, N.Y.

1941 Philadelphia Art Alliance, Philadelphia, Pa.
Photographic exhibition, British War Relief Society and Manhattan Camera Club, New York, N.Y.

1942 Photographic exhibition, Photograph Exhibit Committee of the Citizens Committee for the Army and Navy and Museum of Modern Art, New York, N.Y., traveling exhibition.

1943 "Action Photography," Museum of Modern Art, New York, N.Y.
School of Fine Arts, Yale University, New Haven, Connecticut.

1944 "A Century of Photography," Museum of Modern Art, New York, N.Y., traveling exhibition.

1945 "Creative Photography," Museum of Modern Art, New York, N.Y., traveling exhibition.
"Modern Dance—1945," New York Public Library, New York, N.Y.

1946 Society of the Friends of Art, Cairo, Egypt, (circulated by Interim International Information Service, Office of War Information, New York, N.Y.).

1948 "In and Out of Focus," Museum of Modern Art, New York, N.Y., traveling exhibition.
"This Is the Photo League," Photo League New York, N.Y.

1952 "World Exhibition of Photography," Lucerne, Switzerland.

1954 "This Is the American Earth," California Academy of Science and Sierra Club, San Francisco, California, traveling exhibition.

1955 "C.S. Association Traveling Exhibition of International Photography, 1955-57," London, England, traveling exhibition.
"The Family of Man," Museum of Modern Art, New York, N.Y., traveling exhibition.

1957 "I Am Involved In Mankind," National Conference of Christians and Jews, New York, N.Y.
"I Hear America Singing," United States Information Agency, Washington, D.C., traveling exhibition.
"Volk Aus Vielen Volkern," ("A Nation of Nations"), U.S. Information Agency, Berlin, Germany, traveling exhibition.

1959 "Photographs from the Museum Collection," Museum of Modern Art, New York, N.Y.

1960 "The Invisible World Revealed," George Eastman House, Rochester, New York.
"Photography In the Fine Arts II," Metropolitan Museum of Art, New York, N.Y., traveling exhibition.

1965 Kodak Pavilion, World's Fair, New York, N.Y.
The White House Festival of the Arts, Washington, D.C.

1967 "Photography in the Fine Arts V," Metropolitan Museum of Art, New York, N.Y., traveling exhibition.

1968 Chicago Exchange National Bank, Chicago, Illinois.
"Light 7," Massachusetts Institute of Technology, Cambridge, Massachusetts, traveling exhibition.

1969 "The Art of Photography," National Arts Club, New York, N.Y.
"Spectrum 2: Barbara Morgan, Naomi Savage, Nancy Sirkis," Witkin Gallery, New York, N.Y.

1970 "Be-ing Unclothed," Massachusetts Institute of Technology, Cambridge, Massachusetts.

1971 "Portraits of the American Stage 1771-1971," National Portrait Gallery, Washington, D.C.

1972 "Multiples and Graphics," Katonah Gallery, Katonah, New York.
"Octave of Prayer," Massachusetts Institute of Technology, Cambridge, Massachusetts.
"Ten New England Women Photographers," Wellesley College Museum, Wellesley, Massachusetts.

Selected List of Prints in Permanent Collections

Addison Gallery of American Art, Andover, Massachusetts.

Bennington College Library, Bennington, Vermont.

Chicago Exchange National Bank, Chicago, Illinois and Tel Aviv.

Detroit Public Library, Detroit, Michigan.

History of Photography Collection, Smithsonian Institution, Washington, D.C.

International Museum of Photography, Rochester, New York

Library of Congress, Prints and Photographs Division, Washington, D.C.

Lincoln Center Library and Museum of the Performing Arts, New York, N.Y.

Metropolitan Museum of Art, New York, N.Y.

Museum of Fine Arts, St. Petersburg, Florida.

Museum of Modern Art, New York, N.Y.

National Portrait Gallery, Washington, D.C.

Philadelphia Museum of Art, Philadelphia, Pennsylvania.

Phoenix College, Phoenix, Arizona.

Photography Collection, Massachusetts Institute of Technology, Cambridge, Massachusetts.

Princeton University Library, Princeton, New Jersey.

University of California at Los Angeles Library, Los Angeles, California.

Utah State University Galleries, Logan, Utah.

COLOPHON

Type: Optima
Printing: Rapoport Printing Corp.
Two-Impression Lithography
Binding: A. Horowitz & Son
Paper: Warren's Lustro Offset Enamel Dull